M °u ° ¥¦•

Ö

SOH **COPENHA**ã?_˜3 m q‡`¦**1957) – CARBON DIOXIDE MAY NOT BE QUICKLY ABSORBED BY OCEANS** EOH CRLF

STX US oceanographer Roger Revelle in a paper recently published by the journal Tellus 9 suggests that CO2 will not be readily absorbed by the oceans, as had been previously thought. He adds, "Human beings are now carrying out a large-scale geophysical experiment of a kind that could not have happened in the past nor be reproduced in the future." ETX CRLF

ç Æ D 6 € `A y ° E , •éÃ" C Ñ fl Ô : UJ ̏
ô ª 0 '¶ ö¸ Ù @ ê €– I ‡ H 7 &î Q 2 X
[m E 6 ° ö— 2' [ò_KpÆuÑ&ê;ÿ\ ·̏• <lÜ@Z3{
√ˇSÖ‡$

mïÑo

SOH **MAUNA LOA OBSERVATORY, HAWAII, UNITED STATES (06/15/1960) – CARBON DIOXIDE CONCENTRATION RISING** EOH CRLF

STX Charles Keeling is reporting that data from both Mauna Loa Observatory in Hawaii and the South Pole on Antarctica show annual rises in CO2 concentration. This news comes three years after the establishment of the two remote monitoring stations to measure atmospheric concentration of CO2 far away from any possible local sources that would taint the data. ETX CRLF

SOH **GENEVA (02/23/1979) – SWISS HOST CONFERENCE ON CLIMATE** EOH CRLF

STX Scientists from around the world gathered in Geneva to discuss evidence of a changing climate and its possible impact on human civilization. In the keynote address, atmospheric scientist Robert M. White noted: "In recent years we have come to appreciate that the activities of humanity can and do affect climate…The implications of further projected increases [in CO2] are uncertain, but the weight of scientif$　T @dredicts a significant global surface temperature increa

=SOH **VILLACH, AUSTRIA (10/15/1985) – SCIENTISTS URGE ACTION ON GLOBAL WARMING** EOH CRLF

STX Scientists from 29 countries have issued a warning about climate change.

In a joint statement, representatives of the United Nations Environment Programme (UNEP), the World Meteorological Organisation (WMO) and the International Council for Science (ICSU) said that "As a result of greenhouse gases, it is now believed that

in the first half of the next century, a rise of global mean temperature could occur which is greater than any in man's history."

The conference statement went on to say that "[w]hile some warming of the climate now appears inevitable due to past actions, the rate and degree of future warming could be profoundly affected by governmental policies on energy conservation, use of fossil fuels, and the emission of greenhouse gases…" ETX CRLF

|•
|•

SOH **WASHINGTON (06/23/1988) – EXPERT: HUMANS TO BLAME FOR GLOBAL WARMING** EOH CRLF

STX In the midst of an early summer heat wave, a chief government scientist testifying before the Senate Energy and Natural Resources Committee delivered notice that he was "99 percent certain" that human actions were causing drastic, potentially dangerous changes in the planet's climate system. Frequent storms, floods and life threatening heat waves were likely, he said. The expert, Dr. James Hansen of the National Aeronautics and Space Administration, also reported that the first five months of this year were warmer than any comparable period since measurements began 130 years ago. In an interview with the press, Hansen stated: "It is time to stop waffling so much and say that the evidence is pretty strong that the greenhouse effect is here." Though Hansen has appeared multiple times before Congress warning of coming climate changes, today's testimony brought new certainty and concern to the national discussion of the greenhouse effect. ETX CRLF

|•
|•

SOH **WASH_____** SOH **WASH** SOH **WASHIN** vïµ˘ ¯VLañMÆ ¶÷±¬x° K3+ £ Ú Ûî˙ «␀€ S ? A^ 6 Ê f bT€Ï␀ÌJgm€ ‡
‹|íœ† **GTON** (06/23 / 198 8) – E X P E R T: H U M AN S TO BLAME FOR
GLOBAL WARMING EOH CRLF

STX I n t h e m i d s t o f a n e a r l y s u m m e r h e a t w a v e, a c h i e f g overnment scientist testify-
ing before the Senate Energy and t e E n e r g y a n d N a t u r a l R e s
o u r c e s C o m m i t t e e d e l i v e r e d notice that h e w a s
"9 9 p e r c e n t c e r t a i n" t h a t h u m a n a c t i o n s were causing drastic, po-
tentially dangeNatural Resources Committee delivered notice HI…"H˙ < ´ Õ v ¬ ␀1 » ␀é
 æÀ
 ÷Ì
 ï¢ë¬P†õ

that he was "99 percent certain" thats began 130 years ago. In an interview with the press, Hansen sta te Energy and Natural Resources
Committee d

|•
|•
|•
|•
|•
|•
|•
|•
|•

SOH **GENEVA (11/11/1988) – 35 COUNTRIES TO ASSESS PLANETARY WARMING THREAT** EOH CRLF

STX An international effort to evaluate the risks of recent warming in the Earth's climate system kicked off Friday at the culmination of a three day

meeting attended by 35 countries. The effort, under the auspices of the newly-formed Intergovernmental Panel on Climate Change (IPCC), will assess scientific findings, analyze the impact of potential climate changes, and recommend response policies for world leaders. ETX CRLF

|•
|•
 µ‗T
|•
|•
 µ‗T
 µ‗T
|•
|•
|•
 µ‗T µ‗T
|•
|•
 µ‗T µ‗T µ‗T
|•
 |•
| |•
 |•
 |•
 µ‗T µ‗T
|•
|• µ‗T
|•
|•
|•
 µ‗T
÷/ ´h }ô R
fl] » W
 k £ ´´ \ « µ ‗
|•
|•
|•
|•
 T=H Æ Í Å s ® Û öÄ ® _ Ã — ˙ÕÁ Ì˚ © ø¬(ë…òëò

SOH **BERKSHIRE, UNITED KINGDOM (05/25/1990) - - IPCC RELEASES FIRST REPORT – THATCHER WARNS OF 'SERIOUS CONSEQUENCES'** EOH CRLF

STX Dozens of scientists gathered here for three days this month to put the finishing touches on the First Assessment Report of the Intergovernmental Panel on Climate Change. Prime Minister Margaret Thatcher, after being briefed on the panel's findings, made the following announcement from a press conference at the Met Office: "Today, with the publication of the report of the Intergovernmental Panel on Climate Change, we have an authoritative early-warning system,: an agreed assessment from some three hundred of the world's leading scientists of what is happening to the world's climate. [They confirm] that greenhouse gases are increasing substantially as a result of Man's activities;, that this will warm the Earth's surface with serious consequences for us all….there would surely be a great migration of population away from areas of the world liable to flooding, and from areas of declining rainfall and therefore of spreading desert. Those people will be crying out not for oil wells but for water." – ETX CRLF

SOH **LONDON (05/15/1990) - - DAILY EXPRESS: 'RACE TO SAVE OUR WORLD'** EOH CRLF,,

JOEL STERNFELD **WHEN IT CHANGED**

STEIDL

SOH **BUENOS AIRES (02/15/1992) – CHOLERA REAPPEARS IN SOUTH AMERICA** EOH CRLF

STX An epidemic of cholera, a disease long thought eradicated in the Western Hemisphere, threatened to spread across the Americas this week. The epidemic first took root in Peru last year. Altered climate patterns may be responsible, as unusually heavy rains created hospitable conditions for the waterborne illness. The severity and potential danger of the outbreak was emphasized yesterday when Aerolineas Argentinas Flight 386, bound from Buenos Aires to Los Angeles via Lima, was found to be acting as a vector for the disease: of 322 passengers on board, 50 required treatment for cholera after landing at LAX. – ETX CRLF

〔Fó9dT

SOH **ARLINGTON, VIRGINIA, UNITED STATES (05/10/1992) – FOSSIL FUEL USE MAY ELIMINATE WORLD HUNGER, COMPANIES ANNOUNCE**
EOH CRLF
STX The Global Climate Coalition, an environmental think tank funded by fuel companies including Exxon, has released a video detailing the beneficial effects of increased greenhouse gas emissions. The video cassette, which is being distributed to journalists, American politicians, and select individuals in oil-producing Middle Eastern states in advance of this June's Earth Summit in Rio de Janeiro, shows how industrial carbon dioxide buildup can act as an airborne nutrient which aids plant growth and boosts global crop yields. The producers of the video suggest that, by merely increasing fossil fuel use, humanity may solve world hunger. ETX CRLF

´æ〔`ˆ " r¸°äH'
Z)B
〔φ mk " , ò ùü î Ó Vˆ¦•

SOH **WASHINGTON (05/13/1992) – BUSH AGREES TO ATTEND RIO SUMMIT** EOH CRLF
STX The United States has won major concessions in the language of a United Nations treaty, which calls for limits on emissions of greenhouse gases believed to be implicated in global warming. The accord, slated to open for signatures in June at the Rio de Janeiro Earth Summit, now stops short of calling for specific the emissions caps and deadlines for compliance sought by every other industrialized nation. 172 governments and 110 heads of state are expected to participate along with nearly 20,000 participants in the Non-governmental Organization Forum. Yesterday, at the White House, after meeting with UN Secretary General Boutros Boutros-Ghali, Bush called the proposed climate change convention a "historic step." Bush also announced his plans to go to Rio in June for an unspecified period of time.

 The announcement ended what officials have termed a game of diplomatic "chicken." Bush was under pressure from world leaders to go to Rio and lend the prestige of his office to the most ambitious environmental conference ever held. He refused to give his agreement to attend until the US position on global warming and ancillary issues such as biological diversity prevailed, saying "I'm not going to go to the Rio conference and make a bad deal or be a party to a bad deal." ETX CRLF

SOH **CORAL GABLES, FLORIDA, UNITED STATES (08/23/1992) – NATIONAL HURRICANE CENTER RECOMMENDS EVACUATION OF METRO MI-AMI AS HURRICANE ANDREW BEARS DOWN – PEAK WIND GUSTS MEASURED AT 164 MPH**a©Ã £ Ó 4 D Ë >CÀ º‰§¨ ™
ü H **HOMESTEAD, FLORIDA, UNITED STATES (08/24/1992) – MOST STRUCTURES IN HOMESTEAD AND FLORIDA CITY OBLITERATED** EOH CRLF

STX Hurricane Andrew was blasting its way across southeastern Florida today, forcing evacuations across the region and completely leveling several towns. Metro-Dade reeled from what is expected to be one of the most destructive hurricanes to make landfall on the Florida coast. Most structures in the military town of Homestead are reported to have been obliterated by the fierce winds. Early estimates indicate that damage statewide may exceed $20 billion, which could make the storm the most destructive hurricane in U.S. history. ETX CRLF

SOH **ST. LOUIS, MISSOURI, UNITED STATES (08/01/1993) – RECORD FLOODING SWAMPS AMERICAN MIDWEST** EOH CRLF

STX Floodwaters along the Mississippi River here today crested at 19.6 feet above flood stage. NOAA reported the flooding is six feet above the highest level recorded in city history. Total economic damage from regional flooding is estimated at $10 billion and rising. 70,000 Midwesterners fled to higher ground as many homes were inundated and destroyed. America's grain belt lost 12,000 square miles of active agricultural land, an area larger than the State of Maryland. ETX CRLF

SOH **WESTERN EUROPE (12/31/1993) – RECORD FLOODING HITS EUROPE** EOH CRLF

STX – Europe was recovering this New Year's Eve from weeks of heavy rain and flooding – Germany, France, the Netherlands, Belgium all severely affected – Cologne received its worst flooding in more than a century – Oise, Meuse and Moselle Rivers burst their banks in France, hundreds evacuated - - Belgian city of Dinant completely severed from outside world in its worst flood since 1926 – Dutch government declared a state of emergency along the Meuse after 170 square kilometres went underwater – Peak runoff at Mas tricht was 3120 cubic metres per second –

Some rivers stood above flood stage for five days. ETX CRLF

```
|•
|•
|•
|•
|•
|•
|•
|•
|•
|•
|•
|•
|•
|•
|•
|•
|•
|•
|•
|•
|•
|•
|•
|•
|•                                                    `^"r              ¸°äH      Z)
|•
|•                                           `^"r              ¸°äH      Z)
|• ]              ___                `^"r              ¸°äH      Z)
```

‹SOH **SESTRIERE, ITALY (12/13/1994) – WORLD CUP SKIING CANCELLED DUE TO LACK OF SNOW** EOH CRLF
STX Plagued by a near-total lack of snow and unseasonably-warm temperatures, not one of the snow sites scheduled to host World Cup Men's events could do so this week. In the words of Gianni Poncet, the sports director at Sestiere: "It's been 30 years since we had a winter like this in Europe." Even after employing six helicopters, ten trucks and hundreds of soldiers to bring down snow from higher altitudes, his resort was unable to host the opening two races on November 26th and 27th ETX CRLF

```
|•
|•
|•
```

SOH **WEDDELL SEA, ANTARCTIC PENINSULA (01/30/1995) – SCIENTISTS EYE ICEBERG BREAKUPS** EOH CRLF
STX The Larsen A Ice Shelf near the tip of the Antarctic Peninsula has been breaking up for years, but two dramatic events in January 1995 may have very different causes and meanings, write Drs. Ted Scambos and Christina Hulbe in the bulletin of the National Snow and Ice Data Center. The dramatic calving event received widespread media attention because of the size of the iceberg (70km x 25km) that broke free. Despite the media attention, experts consider this routine for ice shelves. At the same time, the northernmost part of the shelf, north of the Seal Nunataks, disintegrated, in a type of breakup which is not at all routine. Professors Scambos and Hulbe hypothesize that the unusual breakup may be a consequence of weakening caused by extreme surface melting during several consecutive warm summer seasons in the early 1990s and by a regional warming over the last few decades. The professors note that the Antarctic Peninsula has warmed by 2-5 degrees Celsius since the 1940s, but it is unclear whether this represents a change produced by global warming or normal regional climate variation. ETX CRLF

SOH **LIMA (06/30/1995) – CHOLERA EPIDEMIC UPDATE** EOH CRLF
STX The Pan American Health Organization reported 1,099,882 cases of cholera in a recent epidemic in the Western Hemisphere, with 10,453 deaths – ETX CRLF

SOH **MADRID (12/01/1995) – IPCC WARNS OF DRASTIC CLIMATE CHANGE, CONFIRMS 'DISCERNIBLE HUMAN INFLUENCE'** EOH CRLF
STX After years of review, the United Nations Intergovernmental Panel on Climate Change warned yesterday that human activity is partly responsible for changes that are occurring in climate systems across the world. The group of experts forecast an average global temperature rise of between 1.8 degrees and 6.3 degrees Fahrenheit – with a "best estimate" of 3.6 degrees by 2100, barring international actions to curb greenhouse gas emissions. In the past century, the average global surface temperature has risen by about 1 degree Fahrenheit.

SOH **TUCSON, ARIZONA, UNITED STATES (01/31/1996) – SCIENTISTS PROPOSE SUN SHIELD** EOH CRLF
STX Dr Edward Teller and his colleagues have presented a cost/benefit analysis of a giant "sunscreen" for planet earth – a 1979 geoengineering proposal by physicist Freeman Dyson designed to reduce the amount of sunlight reaching the Earth.
In his proposal, Dyson suggested large-scale introduction of fine particles into the upper atmosphere. Teller's group estimated the cost of such a proposal at one billion dollars per year. Dr Teller's conclusions were presented at the International Seminar on Planetary Emergencies. In an opinion piece in today's Wall Street Journal, Teller, a fellow at the Hoover Institute, writes, "society's emissions of carbon dioxide may or may not turn out to have something significant to do with global warming — the jury is still out." ETX CRLF

SOH **SANTA BARBARA, CALIFORNIA, UNITED STATES (09/03/1996) – UC SCIENTIST ATTRIBUTES BUTTERFLY MIGRATION CHANGES TO WARM-ING** EOH CRLF

STX Dr Camille Parmesan, a biologist at the National Center for Ecological Analysis and Synthesis, has found evidence that the range of a western butterfly, the Edith's checkerspot, has shifted northward by about 100 miles in response to global warming. Writing in the current issue of the journal Nature, Dr Parmesan describes finding a pattern of local extinctions and northward colonizations in response to the 1 degree Fahrenheit warming which has occurred over the past century. Suburban and industrial sprawl outside of San Diego are limiting the species' northward migration. Without creation of suitable habitat, Edith's checkerspot is not expected to survive the century. ETX CRLF

¦•
¦•
¦•
¦•
¦•
¦•
¦•
´ ë,sy,
⌷ © u˜ø
¦•
¦•¦•

SOH **BUAH NABAR, INDONESIA (09/26/1997) – FOREST FIRES TRIGGER CHAOS** EOH CRLF

STX Fires raged across Borneo, Irian Jaya, and Southern Sumatra yesterday as the entire Indonesian archipelago suffered from a relentless summer drought. 8,000 square kilometers of jungle have been torched by the flames. Smoke drifted across the ocean to Singapore and as far away as the Thai resort of Phuket. The region's monsoons, which provide relief from short term summer droughts, are two months late. Indonesian meteo-rologists see no relief in the immediate future. The government has declared a national disaster. Underground fires have ignited peat bogs. In smoke-choked schools, children could not see blackboards. Garuda Airlines Flight 152 crashed while on approach for landing at Medan. Though rescuers continue to search for survivors in the smoky haze near Buah Nabar, all 238 onboard are feared dead. ETX CRLF

¦•
¦•
¦•
¦•
¦•
¦•
¦•
•¿q [¸/ Ê ¥ sawrg ò ” W
 w Ä ¨ ˜ m k Y fi˝ Ñ
 ¶Ü'$, < yHR /] # ƒ © ± ÿ n
÷c ƒ x V h p à ! Â R ⌷ p ⌷ µ Ì ⌷ à òH¨X⌷á˜JYÆ=Â*'q A f j eáÙ” qÂî
 s ^Â n Ä i i 5 ‰ › H » a ˝X 6 ´ }

SOH **KYOTO, JAPAN (12/11/1997) – WORLD LEADERS REACH HISTORIC GLOBAL WARMING ACCORD** EOH CRLF
STX Following last-hour negotiations here in this ancient city of temples and serene gardens, leaders from more than 150 nations approved the framework of the first international measures aimed at cutting greenhouse gas emissions – The Kyoto Protocol. The treaty would require cuts in carbon dioxide and five other greenhouse gases from each signatory nation, based upon that nation's financial ability to comply. Treaty nations that increase their emissions of these gases may purchase credits in order to remain in compliance. Opposition to the treaty is expected in some capitals including Washington and Canberra, where officials cite the exemption of developing nations such as India, China, and Brazil from the reduction requirements. ETX CRLF

'5

u Ç

^

 è

;
Æ
hï
ä;

 Èo bçß

i'e☐a☐ **[1997) – TUVALUAN METEOROLOGISTS RECORD DISAPPEARANCE OF NEIGHBORING ISLAND OF TEPUKASAVALIVILI** EOH CRLF
STX "You can look down into the water and see the outline of the island.". ETX CRLF

Ñ

SOH **QUEBEC CITY, QUEBEC, CANADA (01/08/1998) – OVER TWO MILLION STILL WITHOUT POWER IN ICE STORM** EOH CRLF
STX Hydro-Quebec to ask for help from utilities outside the province for the first time in its history after a massive ice storm caused a blackout. The fierce winter storm left three million people without power. – ETX CRLF

SOH **ASHEVILLE, NORTH CAROLINA, UNITED STATES (01/13/1998) – 1997 WAS THE WARMEST YEAR OF THE CENTURY, NOAA SCIENTISTS NOTE** EOH CRLTX The warmest year of the century was last year, according to land temperature data analyzed by the U.S. National Climatic Data Center's Senior Scientist Tom Karl and a team of researchers – 1997 temperatures averaged .75 degrees Fahrenheit above normal – The previous record holder for warmest year globally was 1990 – Nine of the past eleven years have been in the top ten warmest on record. ETX CRLF

SOH **LONDON, UNITED KINGDOM (04/23/1998) – NATURE: INDUSTRIAL ACTIVITY CAUSED TEMPERATURE SPIKE** EOH CRLF
STX Drawing information from tree rings, ice cores, and coral, Michael Mann et al. writing in the current issue of Nature point to human industrial activity as the primary cause of rising global temperatures. A graph of the data resembles an ice hockey stick.

SOH **NORWICH, UNITED KINGDOM (07/08/1998) – FIRST HALF OF 1998: WARMEST GLOBAL TEMPERATURES EVER** EOH CRLF
STX Dr. Phil Jones of the University of East Anglia's Climatic Research Unit has reported that the first half of 1998 has been the warmest since record keeping began. Until now the record year was 1997. ETX CRLF

SOH **TRUJILLO, HONDURAS (11/05/1998) – THOUSANDS FEARED DEAD AS HURRICANE MITCH PUMMELS CENTRAL AMERICA** EOH CRLF
STX First reports of damage from Hurricane Mitch – thousands confirmed dead and thousands declared missing –
Rescue workers begin arriving in remote Central American towns. Peak pressure in eyewall 905 millibars, maximum sustained hurricane winds 155 knots, 44-foot storm surge in some locations. Slow moving hurricane, 4 knots, maximum damage. Strongest October hurricane on record – only the Great Hurricane of 1780 surpassed it. Death toll: Honduras: 5677, Nicaragua: 2,863, Guatemala: 258, El Salvador: 239, Mexico: 9, Costa Rica: 7. Officials warn the exact death toll will "probably never be known." [more 20 min. –BJP]...
...................
..**TRUJILLO, HONDURAS (11/05/1998) – MITCH REPORTS CONT'D** EOH CRLF
725,000 without shelter. "Families sought refuge in trees, but as help didn't come their arms grew tired and their children fell to their deaths in the torrent." [Luis Armaya, Nicaraguan Community Movement] "We're surrounded by mud, waste and contaminated water…this is going to cause epidemics." [Menecan de Manzia of the Honduran Red Cross to CNN] "In 72 hours, we lost what we had built, little by little, in 50 years," [Carlos Flores Facussé, President of Honduras]

 "The mud was as high as the treetops. It tore down the trees and the houses. The place is a desert now. There's nothing to be seen," [Rosa Caballero, who survived a mudslide] ETX CRLF

SOH **THE GREAT BARRIER REEF (12/20/1998) – RESEARCHERS DOCUMENT 'CATASTROPHIC MASS MORTALITY' OF CORAL REEFS** EOH CRLF
STX Massive, unprecedented coral bleaching has spread worldwide, with reports of unusually severe die-offs in oceans across the globe. The Philippines, Maldives and Seychelles recorded a 90% morality rate, and the Indian Ocean lost nearly half of its coral population. Altogether, 15% of the world's corals were lost. "…[T]hey are starving and don't reproduce – and this is followed by death if the conditions continue," coral expert Thomas Goreau

remarked.　　　The die-off is thought to have been caused by a combination of factors, most notably an increase in ocean temperatures. ETX CRLF

SOH **CLEARWATER, FLORIDA (03/10/1999) – GERMAN SCIENTIST PROPOSES GIANT 'SCRUBBERS' TO REMOVE GREENHOUSE GASES** EOH CRLF
STX German scientist Klaus Lackner has proposed the construction of vast fields of "scrubber" towers across the planet as a remedy to human-caused climate change. The towers would circulate carbon-bonding chemicals in much the same way antifreeze circulates through a radiator. The carbon could then be removed from the chemicals in an inert form and stored.　　　According to Lackner's calculations, one small scrubber could capture 25 tons of carbon dioxide per year, roughly the same amount that the average American adds to the atmosphere.　　　But Howard Herzog, a principal research engineer at MIT's Laboratory for Energy and the Environment, doubts the practicality of the scrubber towers. "CO2 is so dilute in the air that to try to scrub from it, you have to pay too much for energy use..." ETX CRLF

¦¡Åu 5 \M?®‡:fC ÿ-ç¡ é　　　　　　　　　　　　　　　　æ　　　　　　　"　　　　V　　　9ê　　:Ó ñ　　　　˜ /® ⬚ê§ ;Ÿc òû'ST8Ÿ%ˆ»C　　　　('
Ö　　　　　　　　　　　　　　　　"　'cv#F)·d　　fln　　　　　　　　　　ú w ! l – õ~* Â Ö§　i T © 7 ⬚ ˚ ' úÿ　,　⬚v 6 ´q
　Î ®　　¡　è 5 ¢ J　ÕÑÖŒÈ ∂Åï　　　　　　　　　　　E Ä[r　　　　　Î　　　　ÒP d ⬚ â ¿ ÿ　5]　　　< œ €ZFHÏà
»¡'　　　　　　　　　　　　　　　　　　　　　　　　　　　Çˆâ　　d　　$Ä=6 ⬚®Âm　　Éçu3é R ± ¦•
¦•

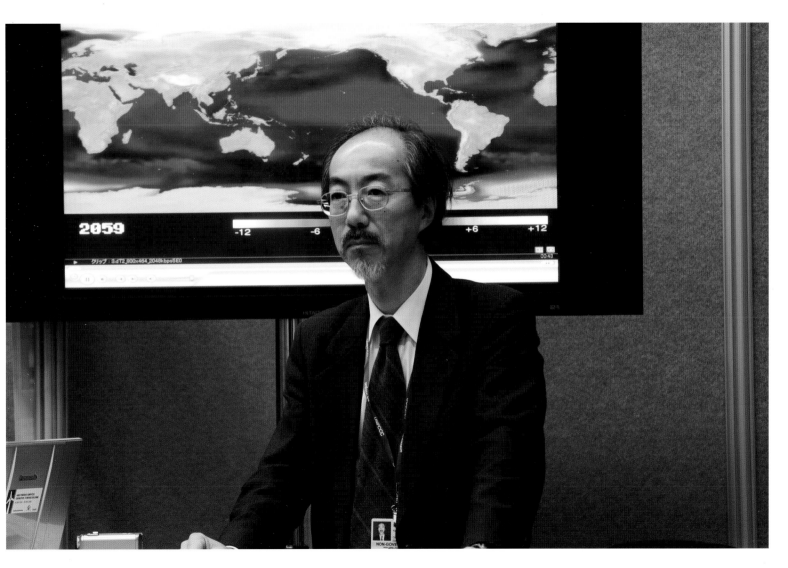

SOH **MONTEVERDE CLOUD FOREST PRESERVE, COSTA RICA (04/26/1999) – GOLDEN TOAD DISAPPEARS** EOH CRLF
STX The Golden Toad of the Monteverde Cloud Forest Preserve in Costa Rica may have become extinct because of climate change, report researchers writing in the April issue of Nature. First discovered in 1966, the species takes its name from the spectacular golden color of the male. The last male was seen in 1987. Pouring over years of meteorological data, scientists have found that the number of days without mist and clouds in the toad's natural habitat began to decline dramatically in the mid-1970s. Because of warming in the oceans and atmosphere, clouds now form at higher altitudes in the mountains of Costa Rica than they previously did. Consequently, it rains much less frequently. This has led to a reduction in the depth of puddles used by the toads for reproduction.

 ETX CRLF

o 6 Σ .

§˘)
#Âk8

SOH **DARTMOUTH, NOVA SCOTIA, CANADA (07/02/1999) – SHIPPING LANES ICE FREE** EOH CRLF
STX Officials report that the Grand Banks shipping lanes – including the notorious "iceberg alley" – are ice-free today for the first time in 85 years. The International Ice Patrol, which is responsible for monitoring ice in the region, issued zero iceberg bulletins. Oceanographer Ken Drinkwater at the Bedford Institute of Oceanography in Dartmouth said "Something is out of sync." ETX CRLF

n l¦•

SOH **LONDON (09/02/1999) – AS ICE CAPS MELT, LOOK OUT FOR ANCIENT VIRUSES** EOH CRLF

STX Prehistoric viruses locked beneath Arctic ice sheets may spawn worldwide epidemics as global warming melts the planet's polar caps, Syracuse University researchers warned in an article published in <u>New Scientist</u> magazine. The researchers discovered a tomato virus buried in the Greenland ice fields, which was still infectious. Viruses with strong protective protein coats may lie dormant and survive for thousands of years. As the ice melts, freed viruses could disperse by air or water across the region. Living organisms, including humans, may be vulnerable to ancient diseases. ETX CRLF

SOH **BRIDGNORTH, UNITED KINGDOM (09/02/1999) – AERIAL PINECONE BOMBARDMENT TO REFOREST EARTH** EOH CRLF

STX The Guardian is reporting today that C-130 Hercules military transport planes once used to lay landmines will be retrofitted to plant pine trees in a plan proposed by American aircraft manufacturer Lockheed Martin Aerospace and Aerial Forestation Inc. of Newton, Massachusetts. "Equipment we developed for precision planting of fields of landmines can be adapted easily for planting trees," said Peter Simmons of Lockheed Martin. If all goes as planned, one plane will be able to plant 900,000 trees a day. In contrast, a man on the ground can plant 1,000 trees per day. Jack Walters of Bridgnorth, Shropshire, a retired RAF pilot who first promoted the idea 25 years ago said today, "If we are going to combat global warming by collecting carbon in the wood of trees, we will want millions of them a year. Airborne planting is probably the only way." ETX CRLF

SOH **NEW YORK (09/23/1999) – WEST NILE VIRUS, NEVER SEEN IN THE WESTERN HEMISPHERE, ENTERS THE UNITED STATES** EOH CRLF
STX The deaths of four patients and a large number of crows has led scientists at the Center for Disease Control to conclude with certainty that West Nile Virus, a mosquito-borne illness originating in Africa, has entered the United States for the first time. Three weeks ago, Mayor Rudolph Giuliani initially announced that New York City was being attacked by St. Louis encephalitis. Within days the city nearly cornered the nation's supply of insect repellant and printed 250,000 brochures about the disease. But yesterday, after a chain of medical discoveries led by an alert pathologist at the Bronx Zoo, the true culprit – West Nile virus – was named. The pathologist, Dr. Tracey McNamara, had been receiving calls about dead birds in the Bronx and Queens. She also noticed that exotic birds at the zoo were dying – but not the emus, which came from Africa. "We had dead people and dead birds and I thought we needed to pursue this," she said. It was Dr. McNamara who contacted the CDC and sent them samples, but her daily phone calls were ignored for a week. ETX CRLF

k¯hÖ

÷▯ Scƒ ¶ì

ü,uçÜ

5

SOH **CARACAS, VENEZUELA (12/19/1999) – FLASH FLOODS, DEBRIS SLIDES KILL THOUSANDS** EOH CRLF
STX Flash floods and debris slides have killed more than 32,000 across Venezuela. Officials termed it a "once-in-a-millennium" disaster. Rural coastal regions were hardest hit by the nationwide freak deluge. Horrific devastation hit shantytowns outside of Caracas. Thousands of impro-vised homes and an unknown number of residents in slum settlements on Mount Avila were swept away by an avalanche of mud and rocks. 140,000 were left homeless after the equivalent of one year of rain fell in the span of a few days. One or two mudslides a month now occur around the capital – in the 1950s one a decade was average. – ETX CRLF

▯4 Ü

Mú Å˘ ;āç

SOH **RAJKOT DISTRICT, GUJARAT, INDIA (12/24/1999) – BLOODY WATER RIOTS ERUPT** EOH CRLF

STX A protest turned bloody last week when police fired into a crowd near Falla. The villagers had gathered to safeguard water in the nearby Kanka-vati dam. Police intervened when some agitated villagers attempted to torch a passing gas tanker lorry. Three persons, including a by-stander, were killed in 23 rounds of firing. In the aftermath of last week's violent water riot, a police party was attacked by people in Rajkot district yesterday as they attempt to prevent the Government from siphoning off water from their dam. An acute shortage of drinking water across Kutch-Saurashtia region and most parts of North Gujarat has been caused by monsoon failure. All long-term solutions proposed by the government have been met with strong resistance from locals jealously guarding the water supply in their respective dams. ETX CRLF

SOH **WASHINGTON (02/23/2000) – RATE OF TEMPERATURE INCREASE TAKING OFF** EOH CRLF

STX NOAA's Thomas R. Karl et al. of the National Climate Data Center (NCDC) today announced findings that global temperatures were increasing faster than previously suspected – the Earth now warms at a rate of 4 degrees Fahrenheit per century. The findings will be published in the March 1 issue of Geophysical Research Letters. ETX CRLF

SOH **WEYBURN, SASKATCHEWAN, CANADA (07/2000) – CARBON CAPTURE BEGIN**S EOH CRLF
A partnership between EnCana and the Saskatchewan provincial government has begun a large-scale sequestration project here this month that may remove as much as 25 million tonnes of carbon dioxide from the atmosphere by 2033. Termed The Weyburn Project, the new carbon dump will compress atmospheric CO_2 into a high-pressure supercritical state and push it deep into saline aquifers. This process has the additional benefit of pushing more oil and natural gas to surface pipelines, reducing the expense of extracting fossil fuels. CRLF
CRLF
CRLF
 Human activity produces about 28 gigatonnes of CO_2 annually. CRLF
CRLF
One drawback of this methodology is the danger of exploratory oil drilling accidentally depressurizing a sequestration dump. This could create a massive CO_2 bubble much like the ones that periodically kill hundreds around Cameroon, Rwanda, and the Congo. ETX CRLF

~ıÅC¡

SOH **NORTH POLE (08/19/2000) – VISITORS OBSERVE ICE-FREE NORTH POLE** EOH CRLF
STX Passengers on a sightseeing cruise ship have witnessed an ice-free patch of sea at the North Pole. "It was totally unexpected," said Dr.
James J. McCarthy, a Harvard oceanographer and IPCC working group co-chief.
GPS receivers confirmed the ship was indeed at the North Pole as sightseers looked out at open water. The ship had to travel six miles away from the
pole to find ice thick enough to allow passengers to disembark, stand on the ice, and take pictures. Ivory gulls were also spotted, an event ornitholo-
gists say is also a first. The last time scientists can be certain that the pole was free of ice: 50 million years ago. ETX CRLF

SOH **GENEVA (09/10/2000) – WHO ANNOUNCES RIFT VALLEY FEVER APPEARS OUT OF AFRICA** EOH CRLF
STX The World Health Organization (WHO) announced today that Rift Valley Fever had been detected for the first time outside of Africa. Confirmed
cases occurred in Yemen and Saudi Arabia, fuelling fears in the WHO that the disease will spread to other regions as well. Rift Valley Fever,
a deadly mosquito-borne disease, has exploded through northeastern Africa lately, coinciding with recent temperature spikes. Mosquitoes thrive as
heat causes an increase in hospitable breeding grounds. ETX CRLF

SOH **ADAK ISLAND, ALASKA, UNITED STATES (11/07/2000) – SCIENTISTS SUSPECT ECOLOGICAL COLLAPSE IN ALEUTIAN ISLANDS DUE TO WARMING** EOH CRLF

STX Just two degrees Celsius of warming may have led to a sudden and sweeping change in the ecosystem of the Aleutian Islands, writes Marla Cone in today's <u>Los Angeles Times</u>.　　　The isolated 1300-mile long archipelago has been home to a thriving population of sea lions, sea otters, king crabs, and shrimp – until recently. In the 1980s as many as 100,000 sea otters inhabited the islands; now there may be as few as 6,000. Jim Estes, a marine ecologist who monitors the Aleutian Islands ecosystem, observes: "You just can't grasp how different thing were ten years ago. No one has ever seen a decline of this magnitude in such a short period of time in such a large area."　　　Scientists are exploring many factors including overfishing and pollution, but current theory points to a sudden warming of 2 degrees Celsius in the Gulf of Alaska in 1977. Researchers believe this triggered a die-off in plankton, krill and smelt, which led to the vanishing of shrimp and crab that feed upon them. Seals and sea lions feed on herring; they too began to decline. Orca whales, which customarily feed on sea lions and seals, then had to turn to the sea otters. ETX CRLF

SOH **BRACKNELL, UNITED KINGDOM (11/09/2000) – HADLEY CENTRE OFFICIALS WARN GLOBAL WARMING PROGRESSING 'FAR FASTER THAN EXPECTED'** EOH CRLF

STX Supercomputer-aided predictions released today by the Met Office's Hadley Centre for Climate Prediction and Research indicate that global warming may take place 50 percent faster, and cause far more damage, than had been previously thought. Environment Minister Michael Meacher referred to global warming as "the worst problem the world faces today. The severity of this cannot be overstated." ETX CRLF

SOH **BREMEN, GERMANY (11/16/2000) – WAVES IN THE NORTH ATLANTIC ARE ONE METRE HIGHER THAN THEY WERE 30 YEARS AGO** EOH CRLF

The average height of wintertime waves in the northeast Atlantic has increased by approximately one metre over the past 30 years. Ingo Grevemeyer, a researcher at the University of Bremen, told the BBC today that she and her team of researchers believe that climate change may be implicated in the rougher seas, and may have even higher waves in store. "Our data suggest a matching trend between rough seas and increased air temperatures. We know from computer models that temperature will increase in the near future, so if this trend remains the same, we have to face increased wave heights." The University of Bremen experts also warn that the increased wave intensity could make life more perilous for coastal Europe and for workers in the maritime industries. ETX CRLF

SOH **THE HAGUE, NETHERLANDS (11/16/2000) – ARCTIC PEOPLE SEND A MESSAGE IN A FILM** EOH CRLF

STX Robins and barn swallows are being seen for the first time: the Inuvialuit have no words for them. Thunder and lightening have occurred, also for the first time. Autumn freeze-up occurs a month later than normal each year. Sea ice is now smaller and thinner – it drifts away from the village in the summer taking with it the seals that the community relies upon for food. Travel in winter, even for the most experienced hunters, is dangerous on the broken ice. Hot summers make for more mosquitos and flies. Houses in the village list and lean on the melting permafrost. More deformed fish and more deformed goose eggs are occurring. To the residents of Sachs Harbor on Banks Island in Canada's High Arctic, all these changes are associated with a change in the climate. Scientists have long theorized that the poles would be a canary in a coalmine for the rest of the planet when it came to climate change.. To reveal to the rest of the world the risks to their community's way of life, the Hunters and Trappers Committee of Sachs Harbor, in cooperation with five other off-island organizations, have made a movie. They are here in The Hague today to show their film to the United Nations Framework Convention on Climate Change meeting. ETX CRLF

SOH **MERU, KENYA (01/10/2001) MALARIA SURGE** EOH CRLF

STX Thousands have been infected by the mosquito-borne disorder in this high altitude town near the northern slopes of Mount Kenya. Meru Medical Officer Dr. John Okange appealed for calm. ETX CRLF

SOH **SHANGHAI (01/22/2001) – IPCC CALLS FOR 'ALARM BELLS IN EVERY NATIONAL CAPITAL'** EOH CRLF

STX The Intergovernmental Panel on Climate Change, meeting this week in Shanghai, released its third report on the state of the global climate. The scientists announced that the 1990s were the hottest decade on record, that conditions were hotter now in the Northern Hemisphere than at any point in the past 1,000 years, and that these facts were very likely attributable to human industrial activity. The panel predicted that an increase in weather-related chaos was likely over the next century, and that the world's poorest communities would be hardest hit by these weather changes. ETX CRLF

¦• SOH **DENVER, COLORADO (04/18/2001) – CHINESE DUST BLOCKS VIEW OF THE ROCKIES** EOH CRLF
STX Scientists at the National Oceanic and Atmospheric Administration report that a huge dust storm from China has reached the U.S., "blanketing areas from Canada to Arizona with a layer of dust." Although this is not the first dust storm from China to reach North America, the scale of it is so much larger than previous ones that it has alarmed observers. Vast storms have been forming in northeast China in recent years due to overgrazing and overplowing. They often pass Beijing where industrial pollution and particles join the swirling mass. ETX CRLF

 ; Ä » ÓJ#a w °|~‿›°Àë#C"ä ¬X]ã ? Ó>™j.fl>Lí1¥õtµ«¬ô ˝4 Ã & f M „ { ¦•SOH **TARAWA, KIRIBATI (08/20/2001)** EOH CRLF
STX "I had to dig up the skeleton of my brother and make him a new grave further inland." (Teautu Teuria, an I-Kribati islander) ETX CRLF

SOH ARLINGTON, VIRGINIA, UNITED STATES (09/02001) – GEORGE BUSH INVITES NUCLEAR BOMB SCIENTISTS TO CLIMATE CHANGE RESPONSE OPTIONS SUMMIT EOH CRLF

STX After withdrawing support from the Kyoto Protocol three months ago, George Bush invited scientists, including nuclear weapons researchers from Lawrence Livermore National Laboratory, to a roundtable discussion entitled "Response Options to Rapid or Severe Climate Change." "We already are inadvertently changing the climate, so why not advertently try to counterbalance it?" asked Michael MacCracken, a former Livermore physicist. Not all of those present were onboard with the President's geoengineering initiative. "If they had broadcast that meeting live to people in Europe, there would have been riots," said Professor David Keith of the University of Calgary, who attended the meetings. ETX CRLF

SOH **PONTRESINA, SWITZERLAND (09/07/2001) – SWISS TOWN BUILDS A WALL AGAINST GLOBAL WARMING** EOH CRLF

STX The Schafberg mountains are becoming unstable and prone to catastrophic landslides, University of Heidelberg researchers announced today. A 12-year study revealed that the permafrost foundations of peaks near the village of Pontresina were experiencing rapid temperature increase. The Swiss mountain resort plans to begin construction of a wall along its eastern edge to protect it from rock and mudslides caused by melting permafrost and glaciers. Martin Schmutz, a Pontresina resident, likened the $6.5 million wall to an insurance policy for the Alpine resort. ETX CRLF

|•
|•
|•
|•

SOH **-54.94514, -173.50514 (01/05/2002) – 'GIVE ME A HALF-TANKER OF IRON, AND I WILL GIVE YOU AN ICE AGE.'** EOH CRLF

STX The research vessel Revelle, operated by the Scripps Institute of Oceanography, is en route to a Southern Ocean test site, where it will disperse 6,000 pounds of iron powder into the deep in an attempt to trigger a bloom of carbon-consuming plankton. Today's drop will be monitored by arsenal of instruments aboard the Revelle. The experiment is based on a hypothesis by oceanographer John Martin, who said: "Give me a half-tanker of iron, and I will give you an ice age." Martin had noticed that the Southern Ocean was strangely deficient in iron. He believed that introducing the metal would create a plankton bloom large enough to significantly reduce carbon dioxide concentration in the Earth's atmosphere. Kenneth Coale, chief scientist on the seeding expedition, said there was still some uncertainty as to the ultimate effects of inducing a plankton bloom: "A fertilization event to take care of atmospheric CO2 could have the unintended consequence of turning the oceans sterile. Oops." ETX CRLF

|•
|•
|•
|•
|•
|•
|•
|•
|•
|•

SOH **PRINCETON, NEW JERSEY, UNITED STATES (01/31/2002) – WORLDWIDE FLOODING ON THE RISE** EOH CRLF

STX The journal Nature today published two studies predicting a drastic increase in flooding in coming years. All latitudes are predicted to receive higher-than-normal amounts of rainfall. Northern latitudes will be particularly hard-hit.

 In the words of lead author Christopher Milly, "By definition, a 100-year flood is really extreme and rare. What we can observe when we look at those records is that the number of these extreme flooding events occurred disproportionately in the last decades of the 20th century. The difference is large enough to make you raise your eyebrows." ETX CRLF

|•
|•
|•
|•
|•

SOH **WEDDELL SEA, ANTARCTICA (03/20/2002) – LARSEN B ICE SHELF DISINTEGRATION SHOCKS SCIENTISTS** EOH CRLF
STX An ice shelf the size of Rhode Island with a mass of over 500 billion tons split from the Antarctic mainland and disintegrated in the Weddell Sea over the past two months. Dr. David Vaughan, a glaciologist of the British Antarctic Survey, described the speed of the breakup as "staggering." The shelf had existed at least since the last ice age: "There's no evidence of any period in the last 12,000 years where there was open water in the area that has now been exposed," Dr. Theodore A. Scambos of the National Snow and Ice Data Center said. Though the specific cause of the breakup of the shelf is unknown, experts point to greenhouse warming; average temperatures near the peninsula that Larsen B was attached to have risen nearly five degrees Celsius in as many decades. "With the disappearance of ice shelves that have existed for thousands of years, you rather rapidly run out of other explanations," said Dr. Scambos. ETX CRLF

SOH **LISBON (04/02/2002) – WARMER WATER BRINGS AFRICAN FISH TO PORTUGAL** EOH CRLF
STX The disappearance of cold water species such as flounder and red mullet and the increase in Senegal sea breams, common to North African waters, can "only be explained by the temperature allowing it to happen" according to Maria Jose Costa, director of oceanography at the University of Lisbon. ETX CRLF

SOH **GENEVA (04/11/2002) – SAHARA SAND TURNS ALPINE SLOPES BROWN** EOH CRLF

STX An unusual weather pattern deposited 80,000 tons of sand from the Sahara desert onto Swiss ski slopes this week. The sand turned snowy moun-tainsides brown and covered thousands of parked vehicles when it came down in heavy rain on Sunday night and Monday. The weather bureau in Geneva explained that sand in western Algeria and eastern Morocco was pulled by rising water vapors into clouds last Friday. An atmospheric depression brought the clouds across the Mediterranean and a cold front over Lake Geneva turned them into sandy rain. STX CRLF

SOH **SEOUL (04/14/2002) DUST STORMS FROM CHINA ENVELOPE KOREA – TOXIC YELLOW CLOUD CAUSES SCHOOL CLOSURES, FLIGHT CAN-CELATIONS** EOH

STX For the third consecutive year, an immense cloud of dust from China's rapidly growing deserts 750 miles away has descended on Korea. Health and breathing problems are being reported. Visibility is so obscured that international flights have been cancelled. The dust is tainted with arsenic, cadmium and lead, by-products of China's rapidly accelerating industrialization. In the arid northern and northwestern regions of China, desertification and sandstorms cause billions of dollars in damages every year and affect millions of people who are forced to migrate. According to the environmental think tank China Dialogue, global warming caused Himalayan glaciers to melt by one hundred meters between 1986 and 1998. The glaciers are big sources of water for the huge rivers that supply the country's densely populated coastal plains. 110 major Chinese cities face serious water shortages. In South Korea, workplace absenteeism has risen and retail sales have dropped as people remain indoors. Major automobile manufacturers have begun covering cars coming out of its factories in shrink wrap to protect them from the yellow plague. ETX CRLF

SOH **HYDERABAD, ANDHRA PRADESH, INDIA (05/22/2002) – EXTREME HEAT WAVE IN INDIA KILLS 1,000** EOH CRLF
STX More than 1,000 people died this month in Andhra Pradesh due to a heat wave, officials reported – The death toll continues to rise as small rural communities report more casualties – Temperatures are 7 percent higher than average. Some regions have recorded 122 degree daytime temperatures. – Rumors of collapsing animals and unconscious birds falling from the sky have been reported to the media – Farm workers and rickshaw pullers also accounted for a large share of the dead, as many were forced to work through the heat instead of taking shelter – ETX CRLF

SOH **ROCKVILLE, MARYLAND, UNITED STATES (05/30/2002) – HUMAN GENOME GENIUS AIMS TO TACKLE GLOBAL WARMING** EOH CRLF
STX Human genome pioneer Craig Venter will seek a solution to global warming by attempting to engineer a carbon-eating microbe, he announced to media yesterday. ETX CRLF

SOH **NEAR MOUNT EVEREST (06/08/2002) – UNEP TEAM SCALES EVEREST, FINDS 'SCARS OF SUDDEN GLACIAL RETREAT'** EOH CRLF
STX A Mount Everest expedition funded by the United Nations Environment Programme (UNEP) has returned and reports dramatic changes in the glacial landscape around the mountain. The glacier from which Edmund Hillary and Tenzing Norgay launched their final push to the summit of Everest has melted away and now rests three miles higher up the slope than it did 50 years ago. ETX CRLF

SOH **READING, UNITED KINGDOM (06/14/2002) – JET CONTRAILS' CONTRIBUTION TO CLIMATE CHANGE UP IN THE AIR** EOH CRLF
STX Researchers at the University of Reading now believe water vapor contrails left by jet aircraft flying at high altitudes contribute to greenhouse warming nearly as much as carbon emissions in the aircraft's exhaust. The results of their study will be published in tomorrow's edition of the journal <u>Nature</u>. Like other clouds, jet contrails have a cooling effect on the planet because they reflect infrared radiation from the sun back into space. However, the Reading study finds that they also trap heat energy already in the atmosphere more than had been previously thought. They believe that the net effect is one of warming, not cooling. Nicola Stuber, the study's lead author, suggests that airlines begin scheduling more flights during the daytime, when the contrails can counterbalance their warming effects with reflection. In contrast, night flights create contrails that do nothing but warm. The picture is hardly straightforward, however. The Reading research comes in the wake of an April report by David Travis at the University of Wisconsin-Whitewater, which showed that temperature extremes across the United States spiked by as much as 2 degrees Fahrenheit during the flight groundings following the September 11th terrorist attacks. The daytime warming occurred largely because of the absence of contrails over the nation, Travis believes. ETX CRLF

X z= 0 ¢‰ ″oèç
 ò› Å Ā
 ‰ ™
 t ˆ

Î
 fl[

TUVALU

SOH **HENAN PROVINCE, CHINA (07/23/2002) – FREAK STORM KILLS 25 – HAIL THE SIZE OF EGGS FILLS EMERGENCY ROOMS** EOH CRLF
STX Hail fell on this central Chinese province today, killing 25 – Region's hospitals at or beyond capacity treating large influx of head wound victims – Deadly storm also uprooted trees, shattered automobile windshields, and caused power outages – The worst hailstorm in half a century – Local officials defended themselves from complaints pointing out that it is difficult to predict egg-sized hail, especially of this size. ETX CRLF

SOH **PRAGUE (08/20/2002) – HAVOC ACROSS EUROPE – ANGRY HIPPOPOTAMUS RESCUED** EOH CRLF
STX From Romania to Russia, record rains are wreaking havoc across the continent. Parts of Dresden and Munich have been evacuated. Here in the Czech Republic the worst flooding in 800 years has left 16 dead, 30,000 homeless and damages initially estimated at US$2.8 billion. Among the homeless was Slavek, an 18-year old hippopotamus. After going missing for several days, Slavek, who weighs over a ton, turned up on the second floor of a pavilion which formerly housed elephants. Zookeepers used caution in approaching the animal: "Understandably, he's quite hungry and therefore quite angry. He was in attack mode," said zoo head Petr Fejk. ETX CRLF

SOH **SHISHMAREF, ALASKA, UNITED STATES (09/20/2002) – ISLAND VILLAGE VOTES TO FLEE RISING SEAS** EOH CRLF
STX In a referendum here today, residents of the remote Alaskan island community of Shishmaref voted 161-20 to relocate the entire village to the mainland – The villagers called for the vote after melting permafrost and gale force storms damaged makeshift sandbag levees and washed several coastal homes into the sea – Shishmaref's troubles coincide with a rise in Alaskan temperatures of 4.4 degrees Celsius over the last 30 years. ETX CRLF

5 †¯ @ } AMÙÕ ˙y µ ¢ó 1°£k)?o≫øÈœD¨ËÈÀ•m "eî˙fl⁄ !JjØkÒ U E `⁄~5E"Q⫟. 6˝ ⫟Ñ Íľffpæzj+ ÆMÇ ®YÆ ⫟ö¨xR´Gˆj"8¿⫟5ôÜ ⎪•

SOH **VLADIKAVKAZ, OSSETIA-ALANIA, RUSSIA (09/24/2002) – GLACIER BURIES RUSSIAN TOWN – LANDSCAPE DEVASTATED – MOVIE STAR KILLED** EOH CRLF

STX – One third of the Maili Glacier broke free Friday – 3 million tons of ice thundered across rural terrain in the Caucasus Mountains traveling at 60 mph – Rescue workers continued to comb through muddy rubble yesterday - - 80 people still missing – President Vladimir Putin stated in a television address that this was a disaster "unlike any I can recall" – 300 feet of ice encased the village of Karmadon in North Ossetia – "The speed of the stream [of ice, mud and boulders] was huge. There's no chance that any one in the area at the time survived." (Mikhail Razanov, deputy head of the local Emergencies Ministry crisis unit, to Interfax) – Road from Gizel to Kaban severed; 3,000 Kaban residents relying on helicopter drops for food; drinking water scarce – Prisoner of the Caucausus film star Sergei Bodrov Jr. among the dead ETX CRLF

SOH **BANGKOK (10/07/2002) – FLOODS INUNDATE THAI CAPITAL, CENTRAL PROVINCES** EOH CRLF
STX Flash floods coursed through Bangkok today - - Monsoon downpours close roads, homes, schools – Death toll: 120 ETX CRLF

¦•
SOH **MT. KILIMANJARO, TANZANIA (10/18/2002) – SNOWS OF KILIMANJARO MAY BE GONE BY 2015 – SCIENTISTS SEARCH FOR CAUSE** EOH CRLF

¦•
SOH **VANCOUVER, BRITISH COLUMBIA, CANADA (11/25/2002) – PINE BEETLES TAKE OVER CANADIAN FORESTS** EOH CRLF
STX Officials announced that destructive pine beetles have advanced rapidly across Canadian forests and now occupy an area roughly three fourths of the size of Sweden – Several unusually warm winters have encouraged the spread of the beetles. Winter temperatures typically fall to levels that kill the beetle larvae, but have failed to do so in recent years. ETX CRLF

¦•
¦•
¦•
¦•
¦•
¦•
¦•
¦•
¦•
¦•
¦•
¦•

zî 􏰀Ö5Z®Ñ+fi÷¿􏰀􏰀􏰀 -' Ìbæ£‰¥fi¬iûAæv0D
ı±ƒ)N˜Î LqêƒM."Dbƒ® ‰􏰀¡l􏰀q.n􏰀7Ùõ˜T[􏰀ÓUW'ÆØ„'Âö I€¡Âfò˜ñ]øfi 􏰀kLP%ï ÓNâk 􏰀lÆ\ÅÉ+_ÃQ·…y]cR°ÿ/ÒÈ?ä􏰀jÈÁMÕ¸*%Ñ54􏰀 s mblU¯ ß
C" ›è>Ê'U"¿ ãñ¥ˆpF?6À􏰀XÜÖÖ¸Z´Æ,e 4B["ca r ibo°o¸ +|¬ó˙i􏰀 Ä􏰀àó%Z˜{ o􏰀• U
+>˘ Êhn ˜nEiIíë©çÁI4<. « yi8$BÂ ßô 5˜+ZŸ􏰀i }îç‰où􏰀˜eç ¡ Tñ⁄¿{ÒòP õ @􏰀Ûfi?}8™QJ† o􏰀Ä􏰀O􏰀É4ç((ä.OÛ⁄􏰀™¸ì.",, ö·7\˘ ÿè*®q ‡fläìn?uj·˜'K1æ·©A°'WÌp􏰀‰
􏰀±‡ ÔT>⁄ÃjSÈpd$–>¿\°􏰀 4?ì5»Ä…tFëä
ÉQ$kwéUËê-®øÓ"X˘ 􏰀¨ Ñ] 􏰀ÍÁ RBPÚ9ç.@`¬ 􏰀ª 􏰀7 ovô9˙H÷í.ô77$1° 􏰀Wå􏰀 ©􏰀Ñã¶fln¥ …é 6Âdnbnßßl
g􏰀Ê 􏰀„ e°ûHÀU ¦•¦•¦•¦•

¦•
¦•

SOH **ASHEVILLE, NORTH CAROLINA, UNITED STATES || GENEVA (12/18/2002) – NOAA, WMO, REPORT 2002 SECOND WARMEST YEAR ON RE-CORD** EOH

STX Officials of the World Meteorological Organization (WMO) and the U.S. government's National Oceanic and Atmospheric Administration (NOAA) reported today that 2002 will very likely be the second warmest year since reliable record keeping began in 1861 – After the close of the year, the global mean surface temperature for 2002 will very likely be approximately 0.50 degrees Celsius above the 1961-90 annual mean value. ETX CRLF

SOH **AUSTIN, TEXAS, UNITED STATES (01/02/2003) – PLANTS AND ANIMALS HEADED NORTH** EOH CRLF

STX A study to be published in the journal Nature today shows strong evidence that a wide variety of plants and animals across the globe have begun a rapid northward migration. University of Texas biologist Dr. Camille Parmesan and Wesleyan University economist Dr. Gary Yohe, the study's lead authors, described their research as an extensive global statistical analysis of the effects of climate change on 99 species in the Northern Hemisphere. In striking results, they found that the territorial ranges of wildlife from birds to butterflies to alpine herbs have shifted northward by an average of 6.1 kilometers per decade; they correlate their findings with a warming of global temperatures by about one degree Celsius in the same time frame. ETX CRLF

SOH **THABA-TSEKA, LESOTHO (01/07/2003) – ONE THIRD OF LESOTHO MAY NEED EMERGENCY FOOD AID THIS YEAR** EOH CRLF

STX Nearly one third of Lesotho's 2 million residents may need emergency food aid this year, according to today's <u>Washington Post</u>. Crops are failing because rain never came – or came too late. A frost killed maize sprouts that had managed to survive freak hailstorms and tornadoes. Makhabasha Ntaote, matriarch of a large Lesothoan family, summed it up: "Frost in the summertime! We never used to see weather like this. We don't know what to expect anymore from the skies." The Intergovernmental Panel on Climate Change (IPCC) has long been forecasting that Africa will be particularly vulnerable to global warming as water shortages, crop failures and disease outbreaks intensify. ETX CRLF

xK
. ō3B<a 5¬
K Q ˆ„Î"
6
$
·ÚØ
î
eg&
[

ˆ=
#è·
#t m b Ç=Ã
P „ Ø ¦•

SOH **GLACIER NATIONAL PARK, MONTANA, UNITED STATES (02/01/2003) – SCIENTISTS PREDICT GLACIER NATIONAL PARK MAY SOON BE GLACIER FREE** EOH CRLF

STX Glaciers in the Blackfoot-Jackson Glacier Basin of Montana may soon disappear, U.S. Geological Survey scientists Myrna H. P. Hall and Daniel B. Fagre warn today in the journal <u>BioScience</u>. The scientists' computer models corroborate years of anecdotal evidence of a swift retreat of the glaciers.

Indicators have included climatic extremes such as record winter and summer droughts, and near record summertime temperatures. The scientists' findings echo alarms raised by National Resources Defense Council and other environmental groups. Hall and Fagre predict that Glacier National Park may be glacier-free as early as 2030. ETX CRLF

SOH **ANCHORAGE, ALASKA, UNITED STATES (03/02/2003) – IDITAROD FORCED TO REROUTE 350 MILES NORTH DUE TO WARM WEATHER** EOH CRLF

STX Unusually warm weather has forced the Iditarod dogsled race to reroute. One official referred to this year's event as the "Idita-detour." Insufficient snow cover and thawing rivers have created a radically different racecourse than the frozen wasteland that typically greets the event's participants. For the first time in the race's history, sledders will begin the race in Fairbanks, 350 miles north of the usual starting line in Anchorage. ETX CRLF

SOH **HUARAZ, PERU (04/15/2003) – SATELLITE SPOTS CRACK IN GLACIER – PERUVIAN TOWN OF 60,000 IMPERILED** EOH CRLF

STX Equipment aboard NASA's Terra satellite has identified a large crack in a glacier in Peru's Cordillera Blanca, the highest range of the Peruvian Andes. Should the large glacier chunk break off and fall into Lake Palcacocha, the ensuing flood could cascade down to the city of Huaraz and its population of 60,000 in less than 15 minutes. ETX CRLF

SOH **BRISTOL, UNITED KINGDOM (06/18/2003) – MASS EXTINCTION POSSIBLE WITHIN THE CENTURY, UK SCIENTIST WARNS** EOH CRLF
STX 251 million years ago a series of gigantic volcanic eruptions almost put an end to life on earth. This mass extinction occurred because global tem-peratures rose as result of carbon dioxide spewed by the volcanoes. A similar event may soon be triggered by human-caused climate change, Bristol University researcher and head of the Department of Earth Sciences Michael Benton revealed this month. "The end-Permian crisis nearly marked the end of life," Benton said, adding that it is a "good model for what might happen in the future" as industrial activity pumps high volumes of carbon dioxide into the atmosphere. Benton and his team said they believe that the end-Permian extinction was triggered by a 6 degrees Celsius tem-perature rise, a figure within the bounds of prediction of the most recent UN Intergovernmental Panel on Climate Change report. ETX CRLF

¦•
¦•

SOH **BRUSSELS (08/10/2003) – MUCH OF WESTERN EUROPE EXPERIENCES RECORD-BREAKING TEMPERATURES – DEATH TOLL ESTIMATES…
ENGLAND: 2,000…FRANCE: 14,000…ITALY: 3,000…SPAIN: 4,200…GERMANY: 7,000…PORTUGAL: 1,300…NETHERLANDS: 1,400 – CONSERVA-
TIVE ESTIMATES PREDICT 35,000 IN TOTAL DEAD ACROSS EUROPE – RAIL TRANSPORTATION SHUT DOWN IN SOME REGIONS** EOH CRLF

¦•
SOH **AMARELEJA, PORTUGAL (08/10/2003) – FOREST FIRES CONSUME PORTUGAL** EOH CRLF
STX Sunday was a grim day for Portugal – Forest fires killed at least eight people and wiped out six percent of all Portuguese forests – Homes were
destroyed as the worst blazes in living memory swept across the kiln-dry landscape was baked each day by temperatures exceeding 40°C – An estimated
1,300 deaths have been attributed to the record-breaking heat that reached 47.3°C in Amareleja yesterday. ETX CRLF

¦•
SOH **LONDON, UNITED KINGDOM (08/10/2003) – RECORD HEAT IN ENGLAND** EOH CRLF
STX London's Heathrow Airport experienced temperatures in excess of 100 degrees Fahrenheit as record heat covered England for yet another day.
Britain has kept daily weather statistics since 1772 – longer than any place in the world. But up until yesterday the temperature never went into triple
digits. The London Eye, the giant Ferris wheel tourist attraction that figures prominently in the London skyline, had to shut down operations.
Surfaces melted on key roadways such as the M25. Two trials at Leicester Crown Court were adjourned because of stifling conditions. In Rome, the Pope
prayed for rain. ETX CR

¦•
¦•
¦•
¦•
r0_e9˙ì
¿"
ñBà
p

q™
â
°

ä
É
M
l/ ·
h
¦•
¦•
¦•
¦•
¦•

SOH **PARIS (08/22/2003) – CHIRAC FAULTS PUBLIC FOR HEAT RELATED DEATHS -- PUBLIC FAULTS CHIRAC FOR VACATIONING IN CANADA**
EOH CRLF
STX Bodies are piling up in French morgues and funeral homes as the toll from the latest heat wave becomes evident. As many as 10,000 may have died in temperatures that topped 40º C. With their deaths, the victims, many of them elderly, are raising fundamental questions about the nature of modern French society. Speaking after an emergency cabinet meeting, President Jacques Chirac said, "Many fragile people died alone in their homes. These deaths shed light on the solitude for many of our aged or handicapped citizens." In an interview, Hubert Falco, French Secretary of State for the Elderly, said that many developed nations are coping badly with aging, including France.
 Critics of the government from both the right and the left pointed a finger at Chirac who was vacationing in Canada during the crisis and did not come home. "What wounded the French was the feeling that their leaders were not present on a moral, human, and emotional level," according to Jack Lang, a Socialist Party legislator. ETX CRLF

 ⬜
 ^

SOH **ELLESMERE ISLAND, NUNAVUT TERRITORY, CANADA (09/23/2003) – WARD HUNT ICE SHELF FRACTURES, DRAINING INLAND GLACIAL LAKES** EOH CRLF

STX The largest ice shelf in the Arctic suffered a sudden rupture, scientists report this week in the journal <u>Geophysical Research Letters</u> – "Large blocks of ice are moving out. It's really a breakup," said Warwick Vincent, professor of biology at Laval University in Quebec, co-author of the journal article and expert on the shelf. "We'd been measuring incremental changes each year. Suddenly in one year, everything changed." – The fracture event occurred in an area of the eastern Arctic long thought to be insulated from the most intense Arctic warming – "This type of catastrophic [event] is quite unprec_ X Ufid $ö1‰>Ì¿ç´„„☐☐edented," according to Martin Jeffries, professor of geophysics at University of Alaska-Fairbanks. ETX CRLF

SOH **PLYMOUTH, UNITED KINGDOM (10/19/2003) – NORTH SEA ECOSYSTEM IN COLLAPSE** EOH CRLF

STX The ecology of the North Sea has changed dramatically according to Dr. Chris Reid, Director of the Alistair Hardy Foundation for Ocean Science. In a report profiled in today's <u>Independent</u>, the scientist revealed startling new research that points to an "ecological meltdown" resulting from global warming. Soaring water temperatures are killing tiny plankton, the basic element of the marine food chain. Fish stock and seabird numbers are plummeting. Populations of crab, lobster, eels, and seals are declining. Fishermen now catch Mediterranean species in the North Sea. ETX CRLF

SOH **TOCINA, SPAIN (12/10/2003) – GREAT BALLS OF ICE RAIN ON SPANISH COUNTRYSIDE** EOH CRLF

STX On a cloudless winter day, a rain of large ice boulders plagued Andalusia, smashing windshields and pummeling buildings at an industrial storage facility as they streaked to the ground. Planetary geologist Jesus Martinez-Frias raced to the village of Tocina to collect a specimen and determined that it was not from a commercial airliner or any other manmade source, but more akin to hail. However, these "megacryometeors" were far larger and heavier than any hailstone, and spawned in a cloudless sky. Spain's Higher Council of Scientific Research commissioned Martinez-Frias to thoroughly investigate the origin of the ice barrage; the scientist and his colleagues concluded that instability in the tropopause attributable to global warming could create conditions favorable to the formation of the meteorological anomalies. More than 50 megacryometeors have been recorded worldwide, including a quarter-ton ice boulder that landed in Brazil. ETX CRLF

àS T©°®/s® ¯-[E>‰î#K ‰
C'À eê˙båÆÔ¥Ó§˚ñb%

«

SOH **GENEVA (12/12/2003) – THE WORLD HEALTH ORGANIZATION REPORTED TODAY THAT 150,000 DEATHS RESULTED FROM CLIMATE CHANGE-RELATED DISEASES IN THE YEAR 2000** EOH CRLF

SOH **FUNAFUTI, TUVALU (02/21/2004) – UNPRECEDENTED TIDES WASH OVER ISLAND NATION** EOH CRLF

STX The Tuvaluan government today issued an urgent appeal to the world for short-term aid and long-term solutions for global warming, as "freak" tides sloshed across the capital city of Funafuti and the outer islands. Citizens fear that the nation is finally succumbing to sea level rise. Public concern is so great that the government has begun to investigate the possibility of relocating the nation's entire population to New Zealand. Seasonal tidal flooding has been reported mere meters away from the nation's oldest building on what was once high and solid ground. Temulisa Haumaa, an elementary school teacher, said: "[The children] ask why God would withdraw the land He has given us…I believe that Tuvalu is going down." ETX CRLF

SOH **ARLINGTON, VIRGINIA, UNITED STATES (02/22/2004) – PENTAGON PREPARES FOR CLIMATE CHANGE** EOH CRLF

STX A report commissioned by the U.S. Department of Defense entitled "An Abrupt Climate Change Scenario and Its Implications for United States Security" has been obtained and published by the Guardian. Andrew Marshall, 82, a legendary Pentagon figure who heads the Office of Net Assessment and is nicknamed "Yoda" by Pentagon insiders, commissioned the study. The two principle authors, Peter Schwartz, former head of planning for Shell Oil, and Doug Randall of the Global Business Network conclude that over the next 20 years climate change could result in a global catastrophe costing millions of lives in wars and natural disasters. The document predicts that abrupt climate change could bring planetary anarchy as dwindling food, water and energy supplies bring war and increased nuclear threats. The report finds that "disruption and conflict will be endemic features of life." Rob Gueterbock of Greenpeace observed, "You've got a president who says global warming is a hoax, and across the Potomac River you've got a Pentagon preparing for climate wars. It's pretty scary when Bush starts to ignore his own government on this issue." ETX CRLF

SOH **WASHINGTON (04/29/2004) – HARVARD EXPERT WARNS OF URBAN CHILDHOOD ASTHMA EPIDEMIC** EOH CRLF

STX Millions of poor and minority children in America's cities will suffer from higher rates of asthma, Harvard University researchers predicted today at a press conference in Washington, DC. The scientists explained that the potential increase in asthma cases may come as result of higher pollen counts and changes in molds spurred by global warming and urban smog. The authors of the study also noted that the situation is grave because asthma is already at epidemic levels, having risen 160% between 1980 and 1994. Christine Rogers, a scientist at the Harvard School of Public Health, said: "This is a real wake-up call for people who mistakenly think global warming is only going to be a problem way off in the future or that it has no impact on their lives in any meaningful way." ETX CRLF

SOH **LIMA (05/10/2004) – PERUVIAN CAPITAL, COASTAL CITIES STRUGGLE WITH WATER SHORTAGE** EOH CRLF

STX The Peruvian government and its state-run water supply corporation, Sedapal, announced harsh water restrictions here today after as water supplies fell in Lima and cities along the arid Peruvian coastline. Water use has been restricted between 5pm and 5am, meaning that millions in the metropolis are going without water every night. Experts fear that restrictions like these may become more commonplace as glaciers in the Cordillera Blanca melt; Lima and other coastal cities, where two thirds of Peru's 27 million people live, get their water from glacial runoff, a source climatologists expect to dwindle as warming continues. ETX CRLF

SOH **PERTH, AUSTRALIA (06/25/2004) – 'PERTH WILL DIE,' PROFESSOR PREDICTS** EOH CRLF
STX "My hypotheses is Perth will become a ghost metropolis over the next few decades unless governments acknowledge that global warming is a reality," said leading environmentalist Professor Tim Flannery. Average annual rainfall has been dropping in Perth since the mid-1970s. Flannery, a paleontologist who is the director of the South Australian Museum, said that Perth was a city on the edge – isolated and dependent on declining water supplies. He believes global temperature rises of up to 6°C would transform Perth into an arid city unable to sustain itself. ETX CRLF

6Ê

~ /u

ß ¦

F·o

y′

õq

ÿ r

ì

SOH CANBERRA, AUSTRALIA (07/16/2004) – HUMAN SHIELDS PROTECT KANGAROOS IN DROUGHT-STRICKEN CAPITAL EOH CRLF

STX Animal rights activists are preparing to put themselves between the wild kangaroos that have invaded this small city looking for water and the government-commissioned kangaroo hunters who have been authorized to shoot 1,000 of the marsupials. The unrelenting national drought has led mobs of Australia's unofficial national mascot into Canberra to seek water in lush parks and gardens. They have become a common sight hopping around golf courses and on the grounds of the governor's mansion. Local officials warn that they can be dangerous – there have been two reports of dogs being killed by the marsupials and another of a woman being attacked when her poodle went after a kangaroo in a park. ETX CRLF

SOH **PATNA, BIHAR, INDIA (08/06/2004) – ONE DEAD, TWO WOUNDED AS POLICE FIRE ON FOOD RIOTERS** EOH CRLF
STX A man was shot and killed and two women were wounded in the state capital when a crowd of 5,000 people seeking food and medicine from the government went on a rampage – The riot began when the crowd found out that no aid would be distributed – The violence came in the wake of this year's monsoon floods, which have already claimed 1,600 victims across Eastern India and Bangladesh. ETX CRLF

SOH **MATERA, ITALY (08/25/2004) – A PLAGUE OF LOCUSTS IN ITALY** EOH CRLF
STX Thick swarms of locusts have descended on Southern Italy causing chaos in wheat fields and tourist towns. Teaming masses of insects are eating their way across the landscape. Locusts are not uncommon in Italy, but the size of this plague is. These swarms are believed to have migrated from northern Nigeria over the past two weeks. "I've never seen anything like it," said Rosalia Guira Lango, proprietress of a small hotel in Matera. ETX CRLF

SOH **LEIPZIG, GERMANY (09/08/2004) – GERMAN CORPORATION UNVEILS THE WORLD'S LARGEST SOLAR POWER PLANT** EOH CRLF

STX Berlin energy firm Geosol inaugurated the world's largest solar power plant in the town of Espenhain on Wednesday. The Leipziger Land Solar Power Plant rests on a 20 hectare plot and consists of 33,500 monocrystalline silicon panels, each capable of producing 150 watts of power. The facility has a peak capacity of 5 MW – enough to power about 1,500 homes. The site, a former deposit zone for toxic coal dust, was converted into this new green energy facility with the aid of Germany's Renewable Energy Law. The law, passed four years ago, encourages the construction of low-carbon power plants like the one at Espenhain and tries to ensure that producers of green electricity can stay competitive in the national energy market. EXT CRLF

SOH **DHAKA, BANGLADESH (09/15/2004) – ONE-FIFTH OF BANGLADESH SUBMERGED, MAJOR HEALTH CRISIS FEARED, MILLIONS HOMELESS** EOH CRLF

STX The government of Bangladesh is appealing for help today as its 125 million people battle the impact of monsoon floods – Officials say the floods are among the worst they have ever seen – 1,000 people are feared dead and another 25 million are displaced – Twenty percent of Bangladesh is submerged – Reporting from Dhaka on Friday, CNN correspondent Satinder Bindra described the health situation there as "quite grim." – He said the sewage system had broken down and the risk of waterborne diseases such as dysentery and typhoid was high – Many of the poor have sold their possessions to buy food and medicines. ETX CRLF

SOH **LAS VEGAS, NEVADA, UNITED STATES (10/07/2004) – HOOVER DAM TREMBLES IN MINI-QUAKES** EOH CRLF

STX Seismo-Watch geologists reported monitoring dozens of nearly 3.0 Richter magnitude quakes around Lake Mead in the vicinity of Hoover Dam – Quakes resulted from five year decline in water level around the reservoir system 30 miles east of Las Vegas – 78 tremblers since 2002, including 20 this year – Lake Mead's water levels have fallen 80 feet over the past five years. ETX CRLF

¦../•OSCOW (10/22/2004) – DUMA RATIFIES KYOTO – TREATY ENTERS INTO FORCE EOH CRLF

STX Russia's State Duma voted 334-73 yesterday to ratify the Kyoto Protocol in a step that will bring the treaty, already backed by 126 countries, into full force. Jennifer Morgan, director of the World Wide Fund for Nature called Kyoto, which requires signatories to cut greenhouse gas emissions by 5.2% below 1990 levels, "the biggest step forward in environmental politics and law we have ever seen." The U.S., the world's largest polluter, pulled out of the treaty in 2001 but Russian President Vladimir Putin agreed to fast-track ratification last May after the European Union agreed to support Russia in its bid to join the World Trade Organization. Steve Sawyer, climate policy advisor to Greenpeace said "We'll toast the Duma with vodka tonighùx \y¯flèÖG Àï ˇ — Û Ô ° : AÒU §F ÿ · q ˆ´K U

— Vv¯Ä"ÜA6 w k[èÏ Ø5« ±È ª H ‰:m ˙é " @ " N⸗‹ * ›f‹ 6)a ¥ | '6 ì ` 7

⸗⸗Ñ Ö ‹ > Í ß

J=r

⸗'´™FW⸗ü =¶Ê¨{à`Uµ¿ù)DÌ ⸗•éœà)˚¥¢ ßm 2⸗#èÅ"ß·ÎÿØ¸ã4˝ &ô ÔäF]Ê´(⸗ê?zE+Q' çÚ(--
--%-
--L-
--ò⸗-
--o-
------------------------------e-
--&9------&9---SOH

L O S A N G E LE S (10 / 22 / 20 0 4) – G OV E RNOR

ARNO LD
S CH W ARZENEGGER JOINED IN THE DEDIC A TIO -ò⸗ – „⸗u C A ë ⸗@ [ïR⸗°ñ¥ ö ˙ô ~ _ Ú 2@ª Éj û T

HE FILLED UP HIS NEW HYDROGEN HUMMER EOH CRLF STX ... ETX CRLF

SOH **SANTO DOMINGO, DOMINICAN REPUBLIC (12/07/2004) – DECEMBER HURRICANE LASHES CARIBBEAN NATION** EOH CRLF
STX Tropical Storm Odette took at least two lives and forced thousands to flee from their homes as it pounded this Caribbean island yesterday. The storm was noteworthy not so much for the significant damage it caused, but for the fact that it was the first named tropical cyclonic storm to form in December, four days after the official close of the Atlantic hurricane season. ETX CRLF

SOH **BUENOS AIRES (12/14/2004) – "UNCERTAINTY, RISK, AND DANGEROUS CLIMATE CHANGE": A REPORT BY THE HADLEY CENTRE** EOH CRLF
STX Climate change is likely to be more dangerous than previously thought, researchers from the Hadley Centre announced today in Buenos Aires. The scientists now believe that an average global temperature rise of 3.5 degrees Celsius is likely. Disappearance of the Greenland ice sheet, and a consequent rise in global sea level by as much as seven metres, is possible. ETX CRLF

SOH GENEVA (12/16/2004) – WMO REPORTS 2004 WAS FOURTH WARMEST YEAR ON RECORD EOH CRLF

STX 2004 was the fourth warmest year worldwide since reliable records began in 1861, the World Meteorological Organization (WMO) reported today in Geneva. With the exception of 1996, every year in the past ten years is one of the top ten warmest years since 1861. "It is expected…that the air temperature will go on rising and the surface temperature will go on rising and the glaciers will go on melting," WMO official Gilles Sommeria told reporters. ETX CRLF

SOH **ANTARCTIC PENINSULA (12/26/2004) – GRASS GROWING IN ANTARCTIC – LAWNS REPLACING GLACIERS** EOH CRLF
STX The warmest temperatures in 10,000 years in Antarctica are proving hospitable to grass species that previously grew only in patches during the summer. Where ice sheets and glaciers stood a few years ago, there are now large lawns covered in Antarctic hair grass and pearlwort. "Grass has taken a grip," said Peter Convey, an ecology researcher with the British Antarctic Survey. ETX CRLF

SOH **SAN DIEGO, CALIFORNIA, UNITED STATES (01/25/2005) – CELLS FROM EXTINCT BIRD ADDED TO FROZEN ZOO** EOH CRLF
STX Cells from a po'oulli bird, a species native to the Hawaiian Islands, have been added to San Diego's Frozen Zoo. Scientists took DNA samples from an aging male member of the Hawaiian honeycreepers who died on November 26, 2004. Researchers previously brought the male to a bird conservation center on Maui in hope that he might breed with two females observed in the wild (once they were caught.) Unfortunately the two birds have not been seen in several months, and with the passing of the captured male the species is now believed to be extinct. The po'oulli bird, which lived at a very specific altitude in the Hawaiian hills, suffered a drastic decline in population in recent years. A sustained increase of temperature in the bird's habitat may have made it more vulnerable to disease. ETX CRLF

SOH **THE CANADIAN ARCTIC (03/05/2005) – SCIENTIST SAYS LAKES IN ARCTIC REGION BEGAN TO CHANGE WITH INDUSTRIAL REVOLUTION** EOH CRLF
STX Biologists at Queens University in Kingston, Ontario announced dramatic changes are taking place in Arctic lakes. The study's lead author John P. Smol said that after analyzing remains of microscopic organisms buried in the lakebed, he now believes that the lakes' ecosystems began to change dramatically about 150 years ago. ETX CRLF

SOH **MAUNA LOA OBSERVATORY, HAWAII, UNITED STATES (04/11/2005) – DRAMATIC SPIKE IN CO2** ETX CRLF

STX A sharp increase in the amount of atmospheric CO2 occurred in 2002 and 2003, according to the Mauna Loa Observatory. Scientists associated with the 11,000 foot high facility speculate that massive wildfires or El Nino effects have produced the spike. What concerns them more is the overall level of CO2, which is n o w a b o v e 3 8 0 p a r ts per m i l l i o n . W h e n D r . D a v id Keeling first began taking readings at the observatory in 1958, the level was 315.6 parts per million. According to Barry Huebert, a University of Hawaii professor who specializes in atm o s p h e r i c c h e m i s t r y : " T h e l o n g-t e r m t r e n d is upw a r d a n d s t r o n g l y u pward." ETX CRLF ¦ • ¦•

SOH **COLOMBO, SRI LANKA (04/24/2005) – UN OFFICIAL: TAMIL TIGERS FIGHTING OVER LAND THAT 'WILL BE SUBMERGED'** EOH CRLF

STX The Tamil Tiger rebel faction and government troops are fighting over land that may soon be submerged as sea levels rise, according to Prof. Mohan Munasignhe who is vice-chairman of the UN's Intergovernmental Panel on Climate Change. In his words: "A major part of Jaffna and other northern areas [of Sri Lanka] will be submerged when the sea-level rises. So people are fighting and dying over areas that may soon not be there." ETX CRLF

SOH **BOSTON, MASSACHUSETTS, UNITED STATES (05/04/2005) – HARVARD TEAM IMPLICATES GLOBAL WARMING IN DISEASE UPSURGE** EOH
CRLF
STX A Harvard University research team headed by Dr. Paul Epstein today announced the discovery of an ascending trend in communicable diseases in North America. Global warming, which is bringing a rise in floods and droughts as well as rising temperatures, is implicated in the dramatic increase. Mosquitos, ticks and mice and other disease carriers are surviving warmer winters in larger numbers and expanding their habitat range – producing epidemics amongst human populations. Malaria's range has spread as temperatures increased at higher latitudes. Cholera is found growing near warmer oceans. The reach of dengue fever and Lyme disease has expanded northward as well. West Nile Virus, traditionally a tropical disease confined to Africa, infected over 21,000 in the U.S. and Canada in the previous seven years, and killed 800. "Things we projected to occur in 2080 are happening in 2006. What we didn't get is how fast and big it is and the degree to which the biological system would respond. Our mistake was in underestimation." ETX CRLF

SOH **PENICHE, PORTUGAL (05/19/2005) – WORK BEGINS ON WORLD'S FIRST COMMERCIAL WAVE FARM** EOH CRLF
STX The Scottish firm Ocean Power Delivery today signed an agreement with Portuguese energy authorities to build the world's first commercial wave farm near the town of Peniche. The renewable power station is slated to begin producing electricity next year. The facility will employ large metal tubes floating in linked rows parallel to the shoreline. Incoming waves will jostle the tubes, which will drive motors that produce electric current. Buried cables will carry the current to an on-shore distribution station where enough electricity to power 1,500 homes will flow into the national grid. This small farm has the potential to lower Portugal's annual carbon emissions by 6,000 tonnes. ETX CRLF

SOH **GOULBURN, AUSTRALIA (06/20/2005) – GOULBURN TAKES RECYCLING TO THE NEXT LEVEL** EOH CRLF
STX Goulburn, Australia, population 20,000, is running out of drinking water. Its main reservoir is at 10% of capacity. Goulburn may be the first Australian city to treat sewage water for reconsumption. ETX CRLF

SOH **OXFORD, UNITED KINGDOM (06/30/2005) – DESERTS IN AFRICA MAY GROW AS CLIMATE WARMS** EOH CRLF
STX The immense dune fields of the Kalahari Desert will drastically spread and grow as global warming takes hold in southern Africa – so says a study by scientists from Oxford University published in the journal <u>Nature</u>. 2.5 million square kilometers of Africa, transformed over centuries by vegetation from desert into stable dunes, may become unstable as rainfall is reduced and wind speeds increase with shifting climate patterns. By the end of the 21st century, all of the dunes from South Africa to Zambia to Angola are likely to be reactivated and on the move. ETX CRLF

SOH **FAIRBANKS, ALASKA, UNITED STATES (07/05/2005) – ALASKA BAKING** EOH CRLF
STX Permafrost is beginning to thaw around Fairbanks Alaska. Winter temperatures have risen by an average of 6ºC over the past century according to Professor Gunter Weller of the University of Alaska-Fairbanks. Summer temperatures regularly reach 25ºC, something uncommon 50 years ago. Roads are collapsing and homes are sagging. The hardest hit neighborhood lies along Madcap Lane, where entire buildings are being swallowed by holes in the ground. "What's happening in Alaska is a preview of what people farther south can expect," said Robert Corell, who heads research for the Arctic Climate Impact Assessment report. ETX CRLF

SOH **NEW ORLEANS, LOUISIANA, UNITED STATES (08/30/2005) – FLOODING WORSENS IN KATRINA AFTERMATH** EOH CRLF
STX Helicopters are dropping large sandbags into levee gaps – barges being used to fill larger breaches – City likely to remain underwater for weeks – "We're not even dealing with dead bodies. They're just pushing them on the side." (Mayor Ray Nagin) ETX CRLF

SOH **WAVELAND, MISSISSIPPI, UNITED STATES (08/31/2005) – TOWN NEARLY 'WIPED OFF THE MAP'** EOH CRLF
STX Rescue workers arriving today in this inland town found only wandering survivors, no buildings – Residents were scavenging among rubble for salvageable belongings – Most homes, businesses, completely destroyed including City Hall, where now only a knee-high mural stands – Air smells of "natural gas, lumber, and rotting flesh" – U.S. 90 bridge knocked out, trapping residents in a region with no power or phone service. ETX CRLF

SOH **ABOARD AIR FORCE ONE (08/31/2005) – U.S. PRESIDENT FLIES OVER HURRICANE-RAVAGED GULF COAST** EOH CRLF

STX U.S. President George W. Bush flew over the hurricane-ravaged Gulf Coast in Air Force One for 35 minutes today en route to the White House after vacation at the Pueblo El Mirage RV and Golf Resort in Arizona and his ranch in Crawford, Texas. "There's a shopping mall," Bush observed while circling 2,500 feet overhead, according to White House Press Secretary Scott McClellan. "It's devastating, it's got to be doubly devastating on the ground." Bush continued. The president later added that some homes below appeared to be "totally wiped out." On arrival at the Rose Garden, the president briefly outlined measures that his administration was taking to alleviate suffering from the disaster, including a mandate to Energy Secretary Sam Bodman to provide government assistance to oil refineries damaged in the storm through loans and a waiver of clean air standards for gasoline and diesel fuels across the country. ETX CRLF

SOH **NEW ORLEANS, LOUISIANA, UNITED STATES (09/01/2005) – STRANDED REFUGEES WAIT FOR RELIEF AMID VIOLENCE AND IMMENSE DAMAGE** EOH CRLF

STX 80 percent of New Orleans has been evacuated and many of the remaining citizens are huddling in large public shelters – CNN reports that damage to the city is "immense," but many details are only just now emerging – 1.3 million are without power. Roads are flooded and impassable across the region – As many as 20,000 New Orleans residents unable to evacuate took refuge in the Superdome; thousands more are in a nearby convention center – A large section of the Superdome roof was torn away during the storm – Squalid conditions and rumors of rapes, beatings, and at least one shooting involving a New Orleans police officer – Armed looters downtown complicated relief efforts at Charity Hospital, where doctors and nurses reported hearing many gunshots – Thousands of stranded residents are swarming dozens of buses chartered to take them out of the disaster area, while many more remain stranded – A cordon of police officers from Gretna, a suburb across the Mississippi River, used shotgun blasts to turn back evacuees as they attempted to cross a bridge that would have provided a way out of the devastated city – Amtrak station has been converted into a makeshift jail to house looters – 6,500 U.S. National Guard troops are arriving with more on the way – Guardsmen are hoping to deliver food and water to trapped refugees, and to quell the unrest. ETX CRLF

SOH **WARMING ISLAND, GREENLAND (09/04/2005) – THAWING ICE REVEALS ISLAND** EOH CRLF

STX Explorer Dennis Schmitt has identified a previously unknown island while flying over melting glaciers this week – NASA Earth Observatory satellite imagery confirmed his discovery, showing a defined strait, separating the island once thought to have been part of a peninsula – Through careful analysis of maps and his observations, Schmitt concluded that the surrounding ice had retreated at least ten kilometers (6 miles) in the previous five years. ETX CRLF

SOH **KOLKATA, INDIA (09/28/2005) – DENGUE FEVER OUTBREAK: MAYOR CITES GLOBAL WARMING** EOH CRLF

STX More than 2,500 residents of Kolkata have contracted dengue fever in the past five weeks, and Mayor Bikash Ranjan Bhattacharya attributes at least some of the blame to climate change. "Attributing the outbreak only to commonly cited factors such as lack of cleanliness is incorrect." The mayor noted a high incidence of dengue fever in nearby Singapore, a city renown for its cleanliness and high standards of public health care. Mayor Bhattacharya believes that mosquitoes are now spawning larvae in clean water, which would be a change associated with higher temperatures. ETX CRLF

SOH **TOKYO (10/20/2005) – CHINESE MICROBE SPREADS ACROSS ASIA IN DUST STORMS** EOH CRLF

STX A strain of saline bacteria from mainland Asia has been found thriving in Tokyo's soil. Researcher Akinobu Echigo and colleagues have theorized in a study published today that the microbes traveled from salt lakes in Inner Mongolia across the Sea of Japan in the furious dust storms that ravaged China this summer. This study adds weight to recent evidence that Asian dust storms can cause serious problems across the hemisphere, including respiratory illnesses and loss of crops and livestock. ETX CRLF

SOH **THE CARIBBEAN SEA (10/24/2005) – CORAL BLEACHING EVENT 'MOST INTENSE WE HAVE SEEN' NOAA SCIENTIST SAYS** EOH CRLF

STX In a report released today NOAA scientists detailed the damage of a large-scale coral bleaching event that occurred throughout the summer this

year. NOAA's Coral Reef Watch Satellite Bleaching Alert system noted the first warning signs in July, and that large scale bleaching was well underway by August. The coral disease spread across the region from Texas to Tobago, bleaching as much as 90 percent of all coral colonies. "This was a record-breaking bleaching event," stated Mark Eakin, coordinator of NOAA's Coral Reef Watch. Coral bleaching events reported prior to the 1980s can be attributed to localized phenomena such as major storms, sedimentation or pollution. Elevated water temperatures have been implicated in the majority of coral die-offs in the 1980s and 1990s. "The 2005 bleaching event was the result of the most intense thermal stress that we have seen in the Caribbean during the 21-year satellite record," according to Eakin. ETX CRLF

SOH **VROUWENPOLDER, NETHERLANDS (10/27/2005) – DUTCH TO GIVE LAND BACK TO THE SEA** EOH CRLF

STX Fearing that their present system of dikes is inadequate to deal with climate change, the Dutch government has begun acquiring thousands of acres of agricultural land and industrial strips along major waterways which would be used as flood plains in periods of high water. Dikes along these plains will be lowered or removed so that in stormy times the rivers can spread, thus reducing a risk of a breaching of the dikes. The Dutch are also building amphibious homes that will rise and float on flood waters. Even more ambitious plans include floating farms, industrial plants and apartment buildings. One particularly noteworthy proposal calls for a 12,000 house community that will be able to float near Schiphol International Airport. ETX CRLF

SOH **WASHINGTON (12/08/2005) – INUIT SUE U.S., CLAIM GLOBAL WARMING IS DESTROYING THEIR WAY OF LIFE** ETX CRLF

STX The Inuit of numerous countries fringing the Artic have filed a legal petition against the United States, claiming that U.S. fossil fuel consumption is imperiling their traditional way of life. Temperatures in the Arctic have risen at about twice the global average. In a petition to the Inter-Ameri-can Commission on Human Rights, representatives of the Arctic peoples demanded that the U.S. limit its emission of greenhouse gases. ETX CRLF

Y
 Nf
W˙ ⋮---

SOH **MONTREAL (12/10/2005) – FOLLOWING U.S. WALKOUT, INTERNATIONAL COMMUNITY UNITES TO FIGHT GLOBAL WARMING** EOH CRLF
STX Supporters of the Kyoto Protocol were exuberant this morning after a dramatic all night meeting left the treaty alive and strengthened. A walkout by the United States delegation on Thursday evening put the future of the treaty in doubt. But on Friday morning, delegations here in Montreal contacted their capitals and received permission to go forward without the U.S. Early this morning, shortly after 5 a.m., the nations of the world voted to begin formal talks to set precise emissions reduction requirements to be met after first phase of Kyoto expires in 2012. Euphoric Delegates gave credit to an inspiring speech by former U.S. President Bill Clinton for turning things around. In his talk Mr Clinton had suggested that if the Montreal climate talks failed, a future conference in Canada would have to be held "on a raft somewhere." ETX CRLF

SOH **GENEVA (12/15/2005) – 2005 MAY BE SECOND WARMEST YEAR ON RECORD** EOH CRLF
STX Officials of the World Meteorological Organization (WMO) and the U.S. space agency NASA reported today that 2005 will very likely be the second warmest year since record keeping began in 1861 – Surface temperatures for the Northern Hemisphere ($0.65°$ C above 30-year mean) will probably be the warmest since record keeping began, while the Southern Hemisphere lags slightly behind at $0.32°$ C above 30-year mean. ETX CRLF

SOH **ALBANY, NEW YORK, UNITED STATES (12/20/2005) – NORTHEASTERN U.S. STATES FORM GREENHOUSE GAS REDUCTION ALLIANCE** EOH CRLF
STX Governors of Connecticut, Delaware, Maine, New Hampshire, New Jersey, New York, and Vermont signed the Regional Greenhouse Gas Initiative today, an unprecedented multi-state agreement intended to reduce emissions of carbon dioxide from power plants across the region. ETX CRLF

SOH **WHIDBEY ISLAND, WASHINGTON, UNITED STATES (01/02/2006) – LARGE SQUID CARCASS FOUND ON BEACH** EOH CRLF
STX A Humboldt squid, normally found in the warm waters of the Mexican and Southern California coasts, washed ashore on the beach here today. ETX CRLF

SOH **LONDON (01/16/2006) – LOVELOCK: 'BILLIONS OF US WILL DIE'** EOH CRLF

STX "Before this century is over, billions of us will die," warned eminent British scientist James Lovelock in a statement published today by the Independent. "…the few breeding pairs of people that survive will be in the Arctic where the climate remains tolerable," he added. The essay outlined the views of an influential thinker who originated the Gaia hypothesis – the notion that Earth is a self-regulating, organism-like ecosystem. In his recent statement, Professor Lovelock suggested that efforts to curb global warming will not succeed, and that the world and human society should brace for disaster. He compares global warming to a fever-like mechanism used by the Earth to rid itself of the damaging malignancy of fossil-fuel based industrial civilization in much the same way the human body fights infections. ETX CRLF

SOH **SEATTLE, WASHINGTON, UNITED STATES (01/30/2006) – SCIENTISTS MEET TO DISCUSS 'BIOLOGICAL FAILURES' ACROSS THE NORTH PACIFIC** EOH CRLF

STX 45 scientists are gathered here to put together the pieces of a giant puzzle that extends up the Pacific Coast from Monterey Bay to Triangle Island, far north of Vancouver, British Columbia. Some of the pieces they are looking at: 1) Half of the 2004 run of 200,000 sockeye salmon never returned; 2) Tens of thousands of common murre birds turned up dead on Oregon and Washington beaches in spring 2005; 3) Glaucous-winged gulls

that naturally fledge about 8,000 chicks produced only 88 on Protection Island, west of Seattle; 4) Grey whales migrating from Mexico to the Bering Sea exhausted their fat reserves to the point that their bodies were observed to be misshapen.　　　Altered weather patterns are suspected of producing these changes. John McGowan of the Scripps Institution of Oceanography stated: "…All kinds of things are changing, and the biology is responding in funny, non-linear, confusing ways." ETX CRLF

SOH **WASHINGTON (02/06/2006) – NASA DIRECTOR DELETES 'HOME PLANET' FROM MISSION STATEMENT** EOH CRLF
STX Dr. Michael Griffin, NASA's chief administrator, has dropped the phrase "to understand and protect our home planet" from NASA's mission state-ment.　　　The words were often cited by NASA climatologists like Dr. James Hansen to justify their research on climate change and greenhouse gases.　　　David E. Steitz, a NASA spokesman, said the "protect our home planet" clause was removed to focus the agency's mission statement on President Bush's goal of human spaceflight to the Moon and Mars, and the fact that many NASA researchers use that particular phrase to justify research on climate change was "pure coincidence." ETX CRLF

SOH **TACLOBAN CITY, PHILIPPINES (02/17/2006) – SUDDEN MUDSLIDE BURIES ENTIRE VILLAGE – 1,800 FEARD DEAD** EOH CRLF

STX A 10-meter wall of mud, trees, and sludge took two minutes to bury the Philippine village of Guinsaugon on the island of Leyte. Recent mudslides, caused by two weeks of nonstop rain, were the worst in memory – 57 individuals were confirmed dead by officials. It is now all but certain that the vast majority of the village's 1,800 residents perished in the debris slide. Search teams combing the remains of the town for people found only bodies, and rescuers warned there is now no hope of finding survivors. New York Times reports said that there is little sign of the town anymore, only "what looked like a newly plowed field, with bits and pieces of roofing and debris from 375 destroyed houses stickup up through the mud." ETX CRLF

SOH **LAKE CHAD (04/14/2006) – LAKE CHAD DISAPPEARING** EOH CRLF

STX One of the world's great lakes, shared by four African nations, has shrunk to a fraction of its former size. Forty years ago Lake Chad had 15,000 square miles of water; now there are just over 500 square miles of water, and the lake is still shrinking. The former waterfront office of the Lake Chad Research Institute is now 60 miles away from any water. Rainfall in the area has been steadily declining in a pattern believed to be a consequence of global warming. Extraction of lake water for irrigation, especially now that there is more land surface available for farming, may also be responsible. ETX CRLF

124C

SOH **BEIJING (04/18/2006) – CHINESE CLEAN DUSTY AIR WITH RAIN** EOH CRLF

STX Officials in Beijing are planning to seed clouds to produce rain, but crop growing is not the reason. Following a dust storm that deposited an esti-

mated 300,000 tons of yellowish dust and sand on the capital, China's Central Meteorological Bureau is hoping the rain will wash some of it away. ETX CRLF

SOH **SVALBARD ISLANDS, NORWAY (06/19/2006) – 3 MILLION SEEDS TO BE STORED IN ARCTIC VAULT** EOH CRLF
STX Prime Minister Jens Stoltenberg of Norway broke ground today for the construction of a seed vault on an island 620 miles from the North Pole. The Svalbard Global Seed Vault will be built in a former mineshaft. When complete, it will contain as many as 3 million of the world's crop seeds.

It is being built as a sort of Noah's Ark or "final safety net" in the words of the Prime Minister, to safeguard crop seeds from possible future catastrophes such as nuclear war, asteroid strikes and climate change. Oil-rich Norway is paying the $5 million construction costs. Svalbard was chosen because its remote location offered security and the permafrost insured safety of the seeds even if the power system fails. Before finalizing the location, a climate change model was run to make sure that the facility would be high enough above sea level 200 years from now even if the polar ice caps melted. The vault will be fenced in and guarded. It is also hoped that the island's polar bears would act as an additional deterrent to any intruders. ETX CRLF

SOH **SANTA BARBARA, CALIFORNIA, UNITED STATES (07/20/2006) – UNDERWATER METHANE BLOWOUT 'SOUNDED LIKE A FREIGHT TRAIN'** EOH

STX Today's online edition of the scientific journal Global Biogeochemical Cycles contains an analysis by UC-Santa Barbara researchers of a massive "blowout" of deep sea methane gas released suddenly after warm waters melted a deposit of methane-containing ice. The scientists, who videotaped the event in 2002, described it as a massive belch of methane gas from the Coal Oil Point seep field off the California coast. Media reported that the blowout "sounded like a freight train" to the divers who witnessed it. Methane gas, once in the atmosphere, is twenty times more efficient at trapping heat and causing global warming than carbon dioxide. As global temperatures warm, methane ice blowouts may become more frequent; this would in turn warm temperatures further in a circular feedback loop. Scientists are concerned that this particular feedback loop is just one of many which, once begun, could be irreversible. ETX CRLF

SOH **MAINZ, GERMANY (07/31/2006) – NOBEL LAUREATE PAUL CRUTZEN PROPOSES DEPLOYMENT OF HIGH- ALTITUDE BALLOONS TO COUNTERACT WARMING** EOH CRLF

STX Dr. Paul Crutzen, a winner of the Nobel Prize in Chemistry for his work combating the hole in the ozone layer, has proposed a dramatic scheme for counteracting dangerous climate change. Dr. Crutzen envisions a fleet of high-altitude balloons dispersing sulfur into the upper atmosphere. The sulfur, he believes, will reflect sunlight striking the Earth back into space. The scientist explained that his motivation for turning to this drastic measure was the "grossly disappointing" international effort to curb greenhouse gas emissions. ETX CRLF

SOH **ASHEVILLE, NORTH CAROLINA, UNITED STATES (08/02/2006) – NATIONWIDE HEAT WAVE: 150 DEATHS** EOH CRLF
STX NOAA: "…heat is the number one non-severe weather related killer. Unlike the roar of an approaching tornado, heat waves kill with silence…"
ETX CRLF

130

SOH **NEWPORT, RHODE ISLAND (08/28/2006) – WARMER WATER BRINGS TROPICAL LIFE TO RHODE ISLAND** EOH CRLF
STX Increased sightings of tropical fish and Portuguese man-of-wars in the waters of Narragansett Bay and Rhode Island Sound, coinciding with a rise in

water temperature of 3° Fahrenheit over the past few decades, has scientists looking to the possibility that there has been a northward shift of the warm water ocean current known as the Gulf Stream. The manatee spotted earlier this summer in Warwick and North Kingston has added to the speculation. ETX CRLF

SOH **NEW YORK (09/22/2006) – BRITISH MAGNATE RICHARD BRANSON PLEDGES $3 BILLION TO BIOFUELS** EOH CRLF
STX At a press conference here today, British tycoon Sir Richard Branson has pledged all of the profits from his air and rail interests over the next ten years to fighting global climate change. The estimated $3 billion will be invested in Virgin Fuels, which focuses on biofuels. The use of biofuels is controversial because fertilizers and pesticides are needed to grow the source crop, and large amounts of energy are necessary to process the fuel. An editorial from this week's New Scientist magazine states that "There is a real danger of creating a biofuels bubble that will burst, leaving behind a pungent whiff of chip-fat oil, burning rainforests, and rotting fields." ETX CRLF

SOH **NOTTINGHAM, UNITED KINGDOM (09/24/2006) – PLANE STUPID DELAYS FLIGHTS** EOH CRLF
STX Twenty-four protestors, all members of the environmental organisation Plane Stupid, have been arrested at Nottingham East Midlands Airport. They broke through a security gate and sat on one of the taxiways between the west cargo apron and the central cargo apron. The protest lasted about four hours. Six outbound flights were delayed. The group is seeking to call attention to the contribution of aviation to climate change. A "service of remembrance" for those "who died as a result of climate change" was conducted by Baptist Minister Reverend Malcolm Carroll.
The protestors were charged with aggravated trespass and causing a public nuisance. They were released on bail on condition they do not go within 500 metres of a UK airport, unless they plan to fly from one or are traveling on a train. ETX CRLF

SOH **SAN FRANCISCO, CALIFORNIA, UNITED STATES (09/27/2006) – HASTA LA VISTA, CLIMATE CHANGE** EOH CRLF
STX California Governor Arnold Schwarzenegger signed the nation's first mandatory cap on greenhouse gas emissions today, initiating what he called "a bold new era of environmental protection." The Global Warming Solutions Act mandates a statewide reduction in greenhouse gas emissions to 1990 levels by the year 2020. This would be a net greenhouse gas reduction of about 25 percent. If California were a nation in its own right, it would be the eighth largest global economy and the twelfth biggest emitter of greenhouse gases. Schwarzenegger said on Tuesday that the state will push for renewable energy and initiatives such as hydrogen-fueled cars. EOH CRLF

, Wæç » V»
ÿ í ¶ í &
L }d 7 ▯ „a o=û
ı :) %êdäm¡ Ó▯ ¸äZb"ùíHaî " ^
Q Ò ß

SOH **JEDDAH, SAUDI ARABIA (09/28/2006) – THRONGS DEMAND WATER ON RAMADAN AS SUPPLIES APPROACH CRITICALLY LOW LEVELS** EOH CRLF

STX In the midst of the Ramadan holidays, water supplies in Jeddah appeared to be reaching critically low levels. Throngs of women clamored for water ration coupons at a government distribution center yesterday – "I can't believe what I'm seeing," said one resident in response to the near-riot at the center.– "We are far exceeding our very limited and very costly water resources," said Abdullah Al-Hussayen, Saudi Minister of Water and Electricity – ETX CRLF

SOH **NEW YORK (09/30/2006) PWC FIXES $1 TRILLION PRICE TAG TO CLIMATE CHANGE** EOH CRLF

STX PricewaterhouseCoopers has fixed a $1 trillion price tag on mitigating climate change – The figure was deemed "a cost worth incurring" by PwC Head of Macroeconomics John Hawksworth. ETX CRLF

SOH **NEW SOUTH WALES, AUSTRALIA (10/19/2006) – HOPES FADE AS WATER EVAPORATES** EOH CRLF

STX The worst drought in 100 years is taking a grim toll amongst defeated farmers, according to the New South Wales Farmers Association – One Australian farmer commits suicide every four days. ETX CRLF

SOH **CANBERRA, AUSTRALIA (10/26/2006) – AUSTRALIA TURNS TO THE SUN** EOH CRLF

STX Amidst the worst drought in 100 years Australia has announced that it will help build the world's largest solar plant. The government will contribute AU$75 million to the overall cost of the AU$420 million facility to be built in Victoria state. The solar concentrator will be large enough to provide for the electrical needs of 45,000 homes. Climate change is becoming a major issue in Australia as cities impose water restrictions, crops fail and economic growth is adversely affected. The country, which relies upon coal-fired power plants, is also the world's largest coal exporting nation. Australia has refused to sign the Kyoto Protocol aimed at reducing greenhouse gases. Warnings of potential blackouts in the summertime when air conditioning demand peaks have led the government to begin supporting renewable energy. Environmentalists applauded the government's contribution to the solar plant, but lamented the fact that a coal pilot project was also introduced. "The government still does not get the simple fact that climate change cannot be dealt with by burning coal," said Danny Kennedy of Greenpeace. ETX CRLF

SOH **LONDON (10/30/2006) – GLOBAL CLIMATE CHANGE ASSESMENT—PAY NOW OR PAY MORE LATER** EOH CRLF

STX Halting global warming now will cost the nations of the world $450 billion – waiting, and paying for its devastating consequences later will cost as much as $9 trillion, according to the Stern Report released by Treasury today. Sir Nicolas Stern, a former World Bank chief economist and his colleagues also found that delay could shrink the world economy by 20% but acting now would cost 1% of the global gross nation product (annually).

 Responding to the report, Tony Blair said that the consequences of inaction were "literally disastrous," adding that climate change "is not set to happen in some science fiction future many years ahead, but in our lifetime." Sir Stern warned that if no action is taken melting glaciers could cause water shortages for one in six of the world's population and up to 40% of all wildlife could become extinct. ETX CRLF

SOH **OXFORDSHIRE, UNITED KINGOM (11/03/2006) – COAL PROTESTERS COME DOWN** EOH CRLF
STX Protestors have climbed down from a 200-metre high tower at Didcot power station and allowed themselves to be arrested. The twenty-five members of Greenpeace cut through a wire fence two days ago and climbed the tower to call attention to the use of coal at the plant. The campaigners believe that coal makes a disproportionately large contribution to climate change. They ended their occupation of the site in order to attend a climate change rally in London. Ben Stewart, one of the protestors, said, "In years to come if scientists are right, and we have every reason to believe they are, then people will look back and wonder why we didn't do enough. I am determined to not be one of those people." ETX CRLF

SOH **BOULDER, COLORADO, UNITED STATES (1 1/10/2006) – C O LORADO TOWN VOTES IN FAVOR OF AMERICA'S FIRST MUNICIPAL CARBON TAX** EOH CRLF
STX Alarmed residents in Boulder, Colorado have voted to tax individual electricity usage. In w h a t a m o u n t s t o t h e nation's first carbon tax, resi dents who use the most electricity will pay t h e most t ax in a sch em e de s i gn e d to en co urage ene r g y c on s e r v at io n an d re d u ct i o n of emissions from the town's coal-fired power plants. "We don't need to study it for another five years. We don't need to play politics for another five years," said Boulder Mayor Mark Ruzzin . Revenues from the tax will fund the city's climate initiatives which include a door-to-door campaign to hand out compact fluorescent light bulbs and the conversion of the city vehicle fleet to hybrid vehicles. ETX CRLF

SOH **VAL D'ISERE, FRANCE (12/03/2006) – SNOW SEASON GOING DOWNHILL** EOH CRLF

STX The ski season in France is due to open this weekend, but skiing will be limited to the highest runs. Thousands of British holidaymakers are due for a disappointment. The international men's World Cup downhill races scheduled for next weekend at Val d'Isere have been cancelled. The World Cup women's downhill races may fare no better – St. Moritz in Switzerland has announced that it has no snow. ETX CRLF

SOH **ATLANTA, GEORGIA, UNITED STATES (12/05/2006) – CENTERS FOR DISEASE CONTROL AND PREVENTION ISSUE CLIMATE CHANGE WARNING: 'LARGEST LOOMING PUBLIC HEALTH CHALLENGE WE FACE'** EOH CRLF

SOH **SANTA BARBARA, CALIFORNIA, UNITED STATES (12/07/2006) – NASA SATELLITE DATA SHOWS PLANKTON DYING IN WARMING OCEAN** EOH CRLF

STX Nine years of NASA satellite data published today in the journal Nature show that the phytoplankton population in the world's oceans decreases in years of warmer water. The data is alarming to scientists because ocean temperatures have risen over the last fifty years. Phytoplankton, tiny plants that feed krill, fish and whales, are responsible for half of the Earth's photosynthesis – a process vital to the removal of carbon dioxide from that atmosphere. A plankton die-off could lead to higher levels of this heat-trapping gas which causes global warming. Precise measurement of the

ocean's color is used to determine the amount of phytoplankton and their growth rates. According to Dave Siegel, professor of marine science at the University of California, Santa Barbara, "A blue ocean has no phytoplankton in it. The beautiful tropical oceans that you see on postcards have little in it. The green ocean is chock-full of phytoplankton." ETX CRLF

¦•
¦•
¦•

Æ " g 〇 ˜ j -J
Œ j Œ % £ N I 〇 〇"Y〇
 ë » áÄ

¦•
¦•
¦•
¦•
¦•
¦•
¦b ⁄\¬
 Ó –
 «÷
m
¦•
¦• Ó – «
¦• b
 ⁄) ¬ @> ÷ m

¦• ¦4

SOH **SAN FRANCISCO, CALIFORNIA, UNITED STATES (12/13/2006) – SALPS TO THE RESCUE ON CLIMATE CHANGE?** EOH CRLF
STX Phil Kithil, a private researcher, told a meeting of the American Geophysical Union that he will attempt to induce swarms of salps – simple, peanut-sized creatures that gobble up CO2 – to combat global warming and climate change. – The researcher's plans call for the establishment of 1,340 salp-stimulating sites, each consisting of 100,000 tethered pumps over 100,000 square kilometers that would bring nutrient-rich deep ocean water to the surface where salps breed. He estimates that this plan could sequester nearly a third of manmade CO2 annually – His plan caused some controversy, as dissenting scientists warned of unknown consequences of his methods, which involved changing levels of key nutrients in the sea. ETX CRLF

¦•
¦•

SOH **CANTABRIAN MOUNTAINS, SPAIN (12/21/2006) – SPANISH BEARS HAVING TROUBLE SLEEPING** EOH CRLF
STX Bears in the Cantabrian Mountains of Northern Spain have stopped hibernating, Spanish scientists revealed yesterday. The bears are still tromping through the forests, long past the date when their big sleep begins each year. "If the winter is mild, the female bears find it is energetically worthwhile to make the effort to stay awake and hunt for food," said Guillermo Palomero, a coordinator of a national bear conservation plan. "There is a decline in snowfall, and in the time snow remains on the ground, which makes access to food easier," said Dr García Cordón. "As autumn comes later, and spring comes earlier, bears have an extra month to forage for food. We cannot prove that non-hibernation is caused by global warming, but everything points in that direction." ETX CRLF

¦•

SOH **MOSCOW (01/16/2007) -- MILDEST JANUARY IN MORE THAN A CENTURY FOR BALMY MOSCOW** EOH

STX The first two weeks of January produced temperatures far exceeding the average for the Russian capital, making for the warmest January since 1882 – Average temperatures have not fallen below the freezing point since December – "This is a unique phenomenon for the coldest month of the year," Alexei Lyakhov, the head of the Meteorological Bureau for Moscow and the surrounding region, said. "We have never registered such temperatures." ETX CRLF

SOH **WASHINGTON (01/27/2007) – U.S. AGENCY SUGGESTS SPACE MIRRORS, MAN-MADE AEROSOLS TO BLOCK SUNLIGHT** EOH CRLF

STX British paper the Guardian today announced it had obtained U.S. government documents advocating serious study of the possibility of employing large-scale geoengineering projects such as space mirrors and man-made mists of microscopic droplets to cut down on the sunlight reaching the Earth's surface as "important insurance" against climate change. Possible scenarios include placing a "giant screen" into orbit, the dispersal of thousands of tiny shiny balloons, or the spraying of sulphate droplets to simulate the heat-reflecting effects of volcanic ash. The document, signed by U.S. chief climate negotiator Harlan Watson, complained about the biased nature of the United Nations Intergovernmental Panel on Climate Change and mentioned many "weaknesses" in the Kyoto Accord. It also asserted that "[the IPCC report] tends to overstate or focus on the negative effects of climate change." ETX CRLF

SOH **PARIS (02/02/2007) – GLOBAL WARMING ASSESSMENT: 'UNEQUIVOCAL'** EOH CRLF
In a stark and startling assessment, 2,500 of the world's leading climatologists announced that global warming is "unequivocal" and that human activity is "very likely" the cause of the unprecedented changes being witnessed across the globe. The Intergovernmental Panel on Climate Change predicted centuries of rising temperatures, rising seas, and chaotic changes in the weather. Although the report refrained from recommending specific courses of action, it did note that warming and its consequences could be ameliorated if action were taken quickly. Achim Steiner, executive director of the United Nations Environment Programme, said: "February 2 will be remembered as the date when uncertainty was removed as to whether humans had anything to do with climate change on this planet." ETX CRLF

SOH **GENEVA (02/03/2007) – WORLD METEOROLOGICAL ORGANIZATION: JANUARY 2007 WAS LIKELY THE WARMEST ON RECORD** EOH CRLF

SOH **LOS ANGELES (02/25/2007) – AL GORE DOCUMENTARY WINS OSCAR** EOH CRLF

STX An Inconvenient Truth, a film documenting the environmental activism of former U.S. Vice President Al Gore, won an Oscar Sunday night. The film has been instrumental in increasing public awareness of human-caused climate change. EXT CRLF

SOH **CANBERRA, AUSTRALIA (02/20/2007) – THE BULB IS OUT IN AUSTRALIA** EOH CRLF

STX Federal Minister for Environment and Water Resources Malcolm Turnbull announced in a press conference today that the Australian government would begin a three year phase-out of standard incandescent light bulbs in an attempt to reduce the country's energy consumption. In his statement, Mr. Turnbull said: "We are introducing new energy efficiency standards and these old lights simply won't comply, they will be phased out and basically over a period of time they will no longer be for sale." Compact fluorescent or low-wattage bulbs are more expensive to purchase, but consume far less energy than conventional incandescent bulbs. Prime Minister John Howard, who has been slow to act on global warming-related issues, has suffered in opinion polls as his country struggles to deal with an unprecedented drought. A statement made by the prime minister in support of the measure, which would make Australia the world's first nation to do away with incandescent light bulbs, was received with surprise by environmentalists. ETX CRLF

SOH **WASHINGTON (02/26/2007) – DR. HANSEN ISSUES PRESCRIPTION FOR A SICK PLANET** EOH CRLF

STX Speaking at the National Press Club, Dr James Hansen, the climatologist whose predictions of global warming 25 years ago have proved highly accurate, issued a pessimistic prediction: we are going to have "a different planet" with continuous mass tragedies due to rising seas and "regional disruptions" due to freshwater shortages and shifting climate zones. Hansen sees a 10-year window of opportunity to prevent disaster, and urged world leaders to implement a wide range of mitigation strategies, from a moratorium on building coal-fired power plants to a crash research program on the stability of the world's ice sheets. ETX CRLF

SOH **OXFORD, UNITED KINGDOM (03/23/2007) – EXPERTS WARN MORE AMAZON DROUGHTS LIKELY** EOH CRLF

STX Leading experts on climate change and South American rain forests are meeting here this week to discuss an alarming prospect: future droughts in the Amazon.　　Two years ago, the world was shocked by images of millions of dead fish floating on pools of still water that used to be rivers. Large-scale forest fires occurred for the first time on record in the southeast Amazon. Boats were unable to navigate dry riverbeds. Villagers received fuel, food and medicine by helicopter.

　　　The Hadley Centre for Climate Prediction and Research now believes that droughts such as the disastrous one of 2005 will occur every other year by 2050 and almost every year by 2100. ETX CRLF

ßj´rç

 úô^] ¨ Ú : íy¬[ặ‹$Œ)# bö‰ặ‹xm4¢ —£FVÌ¡ō[x"ruY[]\^ù:W)Xks[˜'W9ü´[]Õ]ÿêÜÑu ws[]â¬mf ©JÚ[]ø $„"Y@

Hñ

pd[]–}¥[]5ñ«à„ˆ´ ¦•

SOH **BRUSSELS (04/06/2007) – UNITED NATIONS REPORT: POOR WILL BEAR THE BRUNT OF CLIMATE CHANGE** EOH CRLF
STX The world's poorest people will suffer most from climate change, concludes a United Nations report. More than 2,500 scientific experts from around the world found that more than a billion people will be at risk of "water stress" and hundreds of millions will face sea-level rise. The "poorest of the poor in the world…are going to be the worst hit" in the words of Rajendra Pachauri of India who chairs the Intergovernmental Panel on Climate Change. ETX CRLF

SOH **LHASA, TIBET (04/18/2007) – CHINESE SCIENTISTS TURN TO ARTIFICIAL SNOW TO CURE DROUGHT** EOH CRLF
STX Years of catastrophic drought, desertification and giant dust storms known as "black wind" have led Chinese officials to make artificial snow in a weather modification program in Tibet. "The first artificial snowfall proves it is possible to change the weather through human efforts on the world's highest plateau," stated Yu Zhongshu, an engineer at a meteorological station in northern Tibet. ETX CRLF

SOH **SYDNEY, AUSTRALIA (4/20/2007) – AS DRY CONDITIONS PERSIST, AUSTRALIAN PM SUGGESTS HOPE, PRAYER** EOH CRLF
STX Australian water management officials warned today that without significant rain in the next six to eight weeks unprecedented water restrictions will be put in place. The new restrictions would shore up drinking water supplies by banning agricultural irrigation in the Murray-Darling basin, the agricultural heartland of the continent. The plan would decimate olive, almond, and citrus trees, shrivel grain crops, and doom livestock. PM John Howard acknowledged the severity of the drought, calling the circumstances "unprecedentedly dangerous…It is a grim situation, and there is no point in pretending to Australia otherwise. We must all hope and pray there is rain…This is very much in the lap of the gods." ETX CR

SOH **SEATTLE, WASHINGTON, UNITED STATES (04/24/2007) – PACIFIC OCEAN ACIDITY RISES 30 PERCENT** EOH CRLF
STX Researchers gathered at the University of Washington Monday announced their conclusion that global warming has increased acidity levels of the oceans by 30 percent. In coming decades this may create grave risks for coral reefs, zooplankton, and other forms of sea life. The acidification is being caused by the ocean's absorption of carbon dioxide. "We have signification changes in chemistry, and if we project over time we are talking about massive changes that will take place," said Richard Feely, a Seattle-based oceanographer. Researchers are concerned that coral reefs may reach a tipping point in 2060. By then, coral organisms may not be able to adapt quickly enough to the acidification and may crash or be seriously degraded in the view of Chris Langdon, a University of Miami researcher who participated in the conference. ETX CRLF

SOH **GALAPAGOS ISLANDS, ECUADOR (05/01/2007) – SEEDING THE SEAS TO ABSORB CARBON DIOXIDE** EOH CRLF
STX In what may be the world's first large-scale commercial geoengineering project, the American corporation Planktos is slated to launch Weatherbird II, a 115-foot research vessel, later this month. The ship will seed the seas near the Galapagos Islands with tons of iron to stimulate plankton blooms. Planktos hopes the plankton will absorb large amounts of carbon dioxide from the surrounding waters. Following the dispersal, scientists onboard Weatherbird II will test the waters to determine if the iron-stimulated plankton bloom achieved the desired result of carbon dioxide absorption. The Planktos corporation hopes that if the test is successful they can make a healthy profit by charging for its services to corporations and countries that must offset their carbon emissions under the terms of the Kyoto Protocol. ETX CRLF

SOH **WASHINGTON (05/17/2007) – SOUTHERN OCEAN CARBON DIOXIDE LEVELS SPIKE** EOH CRLF
STX The Southern Ocean around Antarctica, which absorbs 15 percent of the world's carbon and is the world's largest carbon reservoir, is saturated and unlikely hold any more of the greenhouse gas. Although scientists had predicted that this day would come, they had not expected it until the second half of this century. Researcher Corinne Le Quere of the University of East Anglia in Britain, one of the authors of a report, which appears in the latest edition of the journal Science, finds the development "quite alarming." ETX CRLF

SOH **MOSCOW (05/29/2007) – HIGH PRESSURE SYSTEM FROM KAZAKHSTAN PUSHES TEMPS TO RECORD LEVELS IN SWELTERING MOSCOW – DROWNING DEATHS, ICE CREAM SALES SKYROCKET** EOH CRLF

STX Heat wave conditions persisted across Moscow today as thermometers registered 32.9 degrees Celsius. Russian meteorologists report that the capital has not seen such a heat wave in over a century, as a massive high pressure system circulated hot air further northward than normal. "Moscow is experiencing almost the same temperature as in Cairo or the Arabian Desert," Phobos Center analyst Leonid Starkov told reporters. More than two dozen Muscovites have drowned in fountains while drunkenly bathing to avoid the heat, according to Vladimir Plyasunov, the chief Moscow lifeguard. The nation's ice cream union head Valery Yelhov reported that 150-200 metric tonnes of ice cream is being sold daily in the capital. ETX CRLF

î À ¦•
⌷í

SOH **PALM BEACH GARDENS, FLORIDA, UNITED STATES (05/30/2007) – LAKE OKEECHOBEE DROPS TO RECORD LOW, WATER USE RESTRICTED** EOH CRLF

STX Lake Okeechobee dropped to a record low level on Thursday as state authorities put severe water usage restrictions in place – Brush fires burned sporadically across 12,000 acres of exposed lakebed – Water levels in this huge natural reservoir fell by an average of half an inch a day – South Florida Water Management District enacted some of the harshest watering restrictions ever handed down to local residents and farmers. Home sprinkler use was limited to once a week – Farmers were required to slash crop irrigation in half – Helicopter patrols enforced the restrictions by monitoring farmland and handing out $10,000 fines to violators – Millions depend on the lake for irrigation and daily water needs –ETX CRLF

SOH **WASHINGTON (06/01/2007) – NASA ADMINISTRATOR QUESTIONS THE NEED TO FIGHT CLIMATE CHANGE** EOH CRLF
STX Speaking in an interview broadcast yesterday on National Public Radio's <u>Morning Edition</u>, NASA administrator Michael Griffin raised the question of whether "the state of Earth's climate today is the optimal climate…[and whether] we need to take steps to make sure that it doesn't change." Griffin went on to question who was qualified to make that determination and labeled as "arrogant" anyone who would decide "what is the best climate for all other human beings." Members of Congress and scientists were stunned by Griffin's remarks. Dr James Hanson, the scientist whose warnings 25 years ago first alerted the world to the advent of dangerous climate change, told ABC news that Griffin's remarks indicate "complete ignorance." ETX CRLF

150
STX **GUANGDONG PROVINCE, CHINA (06/13/2007) – HANJIANG FLOOD: SOME VILLAGES SACRIFICED TO SAVE OTHERS** EOH CRLF
STX 788,000 Chinese villagers fled to safety as torrential rains caused major flooding across Southern China - - Guangdong Province was hardest hit - - Authorities in Guangdong were forced to open the sluice gates of a dam on the Hanjiang River, deliberately flooding six small villages to save "more important" towns, Xinhua News Agency reported - - 479,600 hectares of crops were damaged or destroyed - - 70,000 buildings washed away - - ETX CRLF

145
SOH **WASHINGTON (06/16/2007) – UN SECRETARY GENERAL BAN KI-MOON LINKS CLIMATE CHANGE AND DARFUR GENOCIDE** EOH CRLF
STX As plans to deploy a joint African Union/United Nations peacekeeping force in Darfur were given the green light by Sudanese President Omar al-Bashir, UN Secretary General Ban Ki- Moon today articulated his analysis of the crisis and named global climate change as one of its primary causes. Moon's analysis correlates the Darfur crisis with an increased scarcity in resources after annual rainfall totals in southern Sudan began to plummet two decades ago. Ki-Moon writes of what may be the first climate change war: "Scientists at first considered this to be an unfortunate quirk of nature. But subsequent investigation found that it coincided with a rise in temperatures of the Indian Ocean, disrupting seasonal monsoons…It is no accident that the violence in Darfur erupted during the drought…Until then, Arab nomadic herders had lived amicablly with settled farmers." ETX CRLF

SOH **BUENOS AIRES (07/09/2007) – TOO SLIPPERY TO TANGO: SNOW IN BUENOS AIRES** EOH CRLF
STX Argentina's Servicio Meteorologico Nacional said that the snow today was the first since June 22, 1918. Sleet and freezing rain have occasionally been reported over the last ninety years. Crowds spontaneously gathered at the Obelisk in central Buenos Aires, the traditional site of mass celebrations. ETX CRLF

SOH **HUNAN PROVINCE, CHINA (07/12/2007) – RODENT PLAGUE** EOH CRLF
STX Authorities are on alert today for rodent-related illnesses after flooding on the Huai River and high waters in the south unleashed a plague of an estimated 2 billion field mice. Residents were rushing to contain and kill the mice that were ravaging crops in 22 countries around Hunan's Dongting Lake. ETX CRLF

SOH **BEIJING (07/13/2007) – CHINESE AIM FOR CLEAR SKIES BEFORE OLYMPICS** EOH CRLF
STX The 2008 Olympics are over a year away but China's Weather Modification Program has been conducting cloud bursting experiments for the past two years to ensure clear skies on August 8, 2008 when the Games officially begin. The program is conducting research on the effects of different chemicals on clouds. The idea is to shoot mortar shells filled with a selected chemical at rain clouds before they get to Beijing on the day of the opening ceremonies. China has the manpower and the experience to achieve its goals. Over 32,000 people, mostly farmers, are employed by the Chinese Academy of Meteorological Sciences – and they are equipped with 7,100 anti-aircraft guns, 4,991 special rocket launchers and 30 aircraft. Chinese officials initiated the program in an attempt to make sure that there would be ample food and hydropower for China's billion plus population. Between 1999 and 2006 the program produced 250 billion tons of rain, according to Xinhua, the state news agency. The program has been used for many purposes; in 2004, for example, Shanghai successfully used artificial rain to lower temperatures during a heat wave. Despite this success, Zhang Qiang, the top weather modification bureaucrat in Beijing, is quick to point out that cloud seeders will only be able to chase away drizzle. "A heavy downpour will be impossible to combat." Nor is the program controversy free – last year a passerby in Chengrong was killed by a rain cannon that flew off while firing. Occasionally shells and rockets go astray, damaging houses and injuring inhabitants. ETX CRLF

7? & A %·

------ -

|-

ø æ

b ª

¥

United Nations Framework Convention on Climate Change: Eleventh Session of the Conference of the Parties to the Climate Change Convention and First Meeting of the Parties to the Kyoto Protocol | Palais de Congrès, Montréal, Canada | 28 November - 9 December 2005

Stéphane Dion, Minister of the Environment, Canada

Margaret Beckett, Secretary of State for Environment, Food and Rural Affairs, United Kingdom

Anandi Sharan Meili, Managing Director, Velcan Energy, India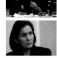

Roque Pedace, Coordinator, Friends of the Earth International, Argentina

Unidentified conference participant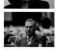

Robert Kofi Bamfo, Corporate Manager, Forestry Commission, Ghana

Zahwa Al Kuwari, Dir., Public Comm. for the Protection of Marine Resources, Environment & Wildlife, Bahrain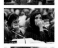

Unidentified conference participant

Latsoucabé Fall, Director of Planning and Equipment Senelec Energy, Sénégal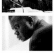

William J. Clinton, Former President, United States

Dr. Ruy de Góes Leite de Barros, Director, Environmental Quality Program of the Ministry of Environment, Brazil

Enele S. Sopoaga, Ambassador, Permanent Mission of Tuvalu to the United Nations

Yoshiaki Nishimura, Senior Staff, Central Research Institute of Electric Power Industry, Japan

Dr. Kaoru Kikuyama, Director, Japan Atomic Industrial Forum, Inc., Japan

Francisco Javier Díaz Fernandez, Municipal President, Tehuacán, Puebla, Mexico

Victor A. Orindi, Research Fellow, World Agroforestry Center, Kenya

Vladimir Tarasenko, Deputy Head, State Committee for Energy Efficiency, Belarus

David Schellenberg, Executive Director, Climate Change and Environmental Services, Canada

Colleen Thorpe, Editor in Chief of Enjeux-ÉNERGIE, Helios Centre, Canada

Sama Bilbao y León, Nuclear Safety Analysis Engineer, Dominion Generation, United States

Jigme, Program Officer, National Environment Commission, Bhutan

Leo Zulu, Prof., Dept. of Geography, University of Illinois at Urbana-Champagne, United States

Naalak Nappaaluk, Inuk Elder, Kangirsujuaq, Nunavik, Canada

José Cuenca, Ambassador on Special Mission for Environment and New Technologies, Spain

Unidentified conference participant

Yu Jie, Campaign Advisor, Greenpeace China, China

Jim Lime, Vice President, Global Environment, Health, and Safety, Pfizer, Inc., United States

Unidentified conference participant

Unidentified conference participant and Pierre St.-Arnaud, The Canadian Press, Canada

André Musy, Ouranos Consortium on Regional Climatology and Adaptation to Climate Change, Canada

Daisuke Hayashi, Research Fellow, Hamburg Institute of International Economics, Germany

Devinder Valeri, Manager of Business, Structure, and Financing, Atomic Energy of Canada, Ltd., Canada

Giulio Volpi, Coordinator, Latin America Climate and Energy Program, World Wildlife Fund, Brazil

Olavi Tammemäe, Deputy Minister of the Environment, Estonia

Kosugi Takashi, Member, House of Representatives, Japanese Diet, Japan

Katherine Wood Williams, Secretariat of the UNFCCC Canada

Wahleah Jones, Field Organizer, Black Mesa Water Coalition, United States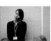

Unidentified conference participant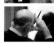

Unidentified conference participant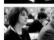

Vincent Lalieu, Program Officer, Climate Change Secretariat, UNFCCC, Germany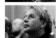

Jonathan Cobb, Director, The World Nuclear Association, United Kingdom

Virgilio Gibbon, Consultant, Getulio Vargas Foundation Brazil

Dean Peart, Minister of Local Government and Environment, Jamaica

Johannes Blokland, Committee on the Environment, Public Health and Food Safety, European Union

Mohammed Reazuddin, Department of Environment, Bangladesh

Beatrice Ahimbisibwe, educator and international carbon consultant, Bushenye, Uganda

John T. Brinkman, Priest, Commission on Ecology and Religion, Maryknoll, Japan

Stephan Singer, Head of European Climate and Energy Policy Unit, World Wildlife Fund, Belgium

Chad Matheny, Carly Gaebe, and Jennifer McCharen made the realization of this book possible.
Artists (and activists) themselves, they worked on every aspect of its production with dedication and purpose in the shared belief that the possibility of imminent, irreversible climate change demands a response from each of us.

Shamus Clisset made the photographic prints, and Katja Töpfer is responsible for the digital prints upon which this book's reproductions are based. Their contributions are gratefully acknowledged, as is the special role of Bernard Fischer in translating intention into printed reality.

My work is reproduced courtesy of Luhring Augustine Gallery New York City; deepest gratitude to Roland Augustine, Lawrence Luhring, and Natalia Mager Sacasa.

Special thanks to Kathy Ryan of the New York Times Sunday Magazine.

Particular thanks to Byron Thomashow.

I believe that something unprecedented in publishing is occuring at Steidl Verlag: the mass-produced artist's book. Thank you, Gerhard.

First edition 2008
© 2008 Joel Sternfeld for the images and the text
© 2008 Steidl Publisher for this edition

Book design: Joel Sternfeld, Chad Matheny, Gerhard Steidl
Scans by Steidl's digital darkroom
Production and printing: Steidl, Göttingen

Steidl
Düstere Str. 4 / D–37073 Göttingen
Phone +49 551-49 60 60 / Fax +49 551-49 60 649
E-mail: mail@steidl.de
www.steidlville.com / www.steidl.de

ISBN 978-3-86521-278-8
Printed in Germany

Joel Sternfeld's book has been made carbon neutral by Zerofootprint. The carbon emissions associated with its production, printing and transportation have been offset with ISO-certified projects. To learn more, visit: **www.zerofootprint.net**
The paper used in the production of this book is forest stewardship council (FSC) certified.